IMAGES
of Rail

ULSTER COUNTY
RAILROADS

IMAGES
of Rail

ULSTER COUNTY
RAILROADS

Stephen Ladin and Glendon Moffett

ARCADIA
PUBLISHING

Published by Arcadia Publishing
Charleston, South Carolina

Printed in the United States of America

Library of Congress Control Number: 2011923098

For all general information, please contact Arcadia Publishing:
Telephone 843-853-2070
Fax 843-853-0044
E-mail sales@arcadiapublishing.com
For customer service and orders:
Toll-Free 1-888-313-2665

Visit us on the Internet at www.arcadiapublishing.com

This book is dedicated to Beckett "Lucky" Ladin. Beckett loved riding trains and trolleys, especially in the company of his young friends, and he loved running and hiking the rail trails.

CONTENTS

ACKNOWLEDGMENTS

There are so many people who have dedicated themselves to keeping history alive. Professional historians write books, create films, and record oral histories, which ensure that while the past fades away, future generations can go back to travel through time.

Our contributors have been credited alongside the images they graciously allowed us to use. Public collections from libraries, historical societies, and educational institutions assure that the historic record survives. The collections of private collectors, in most cases, have been a labor of love, acquired at their own personal expense. With the limited resources of historical organizations, private collectors play an essential role in preserving history; in some instances, their stewardship of historic artifacts exceeds that of many museums and libraries.

We wish to thank Chester Hartwell, Nick Driano, Carol Johnson, Ken Gray, Joan LaChance, Kenny Darmstadt, Edward Pine Sr., Vivian Yess Wadlin, Estelle and Thurlow Weed Jr., Elizabeth Alfonso, Edmund Hopper, Charles Edward Courtney papers collection, Cornell University Library, Evan Fay Earle, Cornell University, Elizabeth Werlau, Shirley V. Anson, Dorothy Gruner, Frank Lombardi, Glenn Clarke, Anthony Palazzo, Marty Lou Mahan, Frank Palazzolo, J. Michael Leister, Gail Russell, Lonnie Gale, Peg Gale, Dakin Morehouse, Muriel "Mickey" Obermeyer, Robert Haines, and Marty Lennox.

The Catskill Mountain Railroad and the Trolley Museum of New York operate on different sections of track, which were part of the Ulster & Delaware Railroad (U&D). The Empire State Railroad Museum occupies a restored Phoenicia Railroad Station, also part of the U&D. These three organizations give to us the opportunity to travel back through time. They offer rides along sections of track that have not changed through recent times; they present exhibits and programs offering the public a glimpse of our history.

Many railroad right-of-ways have been replaced by rail trails. The Wallkill Valley Rail Trail Organization, the Hudson Valley Rail Trail, the Hurley Rail Trail, and Walkway Over the Hudson also play a prominent role in preserving the history of the railroads.

INTRODUCTION

There are many ways to gauge and interpret history.

The growth of the railroads in the United States tells us about our industries and our economy. It coincides with America becoming the dominant player on the world stage; one would not have happened without the other.

If we look more closely, it provides us with a census, of sorts. We can almost figure out how many people there were, what they did for a living, and where they lived.

The story of the railroads is multifaceted. It is about the machinery: where it traveled, how it got there, and what it carried. Just as important and interesting are the people associated with the railroads: the owners, managers, workers, and passengers.

Finally, it is about the infrastructure: the buildings, bridges, towers, and the other physical elements essential to the operations.

The five railroads of Ulster County served the people and industry in the Mid-Hudson Valley and Catskill Mountains of New York State. Ulster County was rural in character, with no population centers. It possessed a natural beauty and raw materials, the essential elements in the growth of our nation.

Natural cement, mined and processed in Ulster County, was prized for its durability. Many monumental structures built during the growth of America, such as the Statue of Liberty, the Washington Monument, and the Brooklyn Bridge, were built with Rosendale Cement. Local contractors marvel and complain about Rosendale Cement, at how long it has continued to last without deteriorating and how difficult it is to demolish. The railroads of Ulster County were one of the shipping links to the outside world for natural cement.

The growing importance of New York as a financial and manufacturing center, international port, and a major point of entry for immigrants from Europe (and Asia) was a major factor in the growth of the railroads. The local dairy farms, which still existed in the five boroughs of New York City in the early 20th century, began to disappear with the growth of the population within the city limits. Fresh milk, meat, and other produce came from Ulster County, arriving unspoiled, without modern means of refrigeration, to be consumed at the metropolitan markets of New York City everyday.

How often is there a reference, in a book or movie, of a character setting the accuracy of his timepiece by the arrival of a train? Such was the fabled dependability and on-time performance of the railroads of yesteryear. Sadly, as our modes of modern transportation have sped up, they more often than not deliver their cargo late.

As population centers, such as New York and Philadelphia, began to lose their rural character, a newly minted middle class with leisure time needed an escape from the fast-paced life of a burgeoning industrial landscape. The railroads began serving a population wishing to escape to the country. Ulster County, with its natural beauty, welcoming mountains, and proximity to a vast market, offered such a place, and the railroads played a major role building a tourist industry accessible to a new middle class. A family could travel from Philadelphia in the morning and arrive in Ulster County later in the day, none the worse for their day of travel.

Many of the structures built in service to the railroads were not modernized or upgraded over their lifetimes. They faded away as the modern era took over. On lucky occasions, some of the structures were restored and rehabilitated either for alternate use, or as homes for museums and historical societies. Some of the railroad stations have become private residences, the objects of great pride of their residents and owners. On other occasions, they were demolished, with little or no evidence left of their existence. The images of this decline convey sadness, a feeling of melancholy and loss.

More uplifting are the portraits of the people of the railroads. The lifetime length of their employment, their dedication and pride in their jobs, their membership in what they considered an exclusive fraternity leave us a legacy of what America used to be.

There is another interesting and unique narrative that accompanies the history of the railroads. In the name of progress, we lose historic structures and artifacts almost everyday. In many instances, even from a historic perspective, not everything is worth saving. Rail trails have become among the most popular attractions used by a wide cross section of our population. Because of the unique laws applied to the railroads, right-of-ways have survived intact. Even as the right-of-ways travel through the backyards of private residences, they were not often encroached upon. Citizens groups, conservation organizations, municipal townships, and other government entities have taken over abandoned right-of-ways and converted them into what we know today as linear parks. Rail trails are a perfect accompaniment to our modern lifestyles, dedicated to healthy activity. We can hike, run, bike, and ski along them, without expending much effort in imagining what it must have been like to experience the countryside as it was 100 years ago. They are places where we walk our dogs and stroll with our family and friends. They have become community meeting places.

Kingston, New York, was the first capital of New York State, if only for a short time. It was a crossroads, bounded by farms, natural resources, industry, recreational assets, and the Hudson River. Of the five railroads of Ulster County, four went through Kingston. The Delaware and Hudson Canal terminated in Kingston. The history of Kingston can be traced through the growth and decline of the railroads. The only remnants of the five historic railroads of Ulster County are the freight trains of the CSX Corporation as they travel through Kingston on the tracks of the West Shore Railroad. Sadly, the railroad no longer plays a role in the economic and resultant cultural life of the city. Freight and passengers must go elsewhere to find a rail terminal.

One

THE PEOPLE, PLACES, AND MACHINES

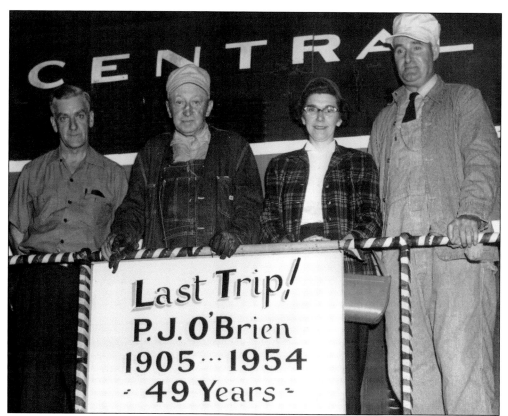

A good way to begin a story about the railroads is to have a look at the people who worked on or used the railroads. The images are revealing. They carry more than words. Readers see what it must have been like to live in these bygone eras and what the landscape looked like then. (Courtesy of Robert Haines.)

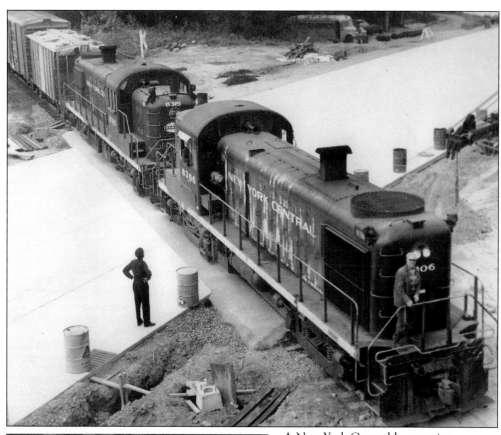

A New York Central locomotive is crossing Washington Avenue in Kingston around 1960. (Photograph by Robert Haines.)

This is a photograph of an employee receiving an award, probably honoring his service on the railroad. (Photograph by Robert Haines.)

In almost every photograph, the men (and in a few instances, women) are happy in their work. As many photographs illustrate, even while performing extremely difficult physical labor under extraordinarily bad conditions, the comradeship among the workers is evident. (Courtesy of Robert Haines.)

Robert "Bob" Haines's father was an engineer with the railroad. Haines developed an interest in photography, which coincided with his love of the railroads and railroading. His interest led him to a profession as a photographer with the *Kingston Daily Freeman*. Haines was often called upon to photograph retirements and other noteworthy events. Additionally, insurance companies called him to document train wrecks as they occurred. (Photograph by Robert Haines.)

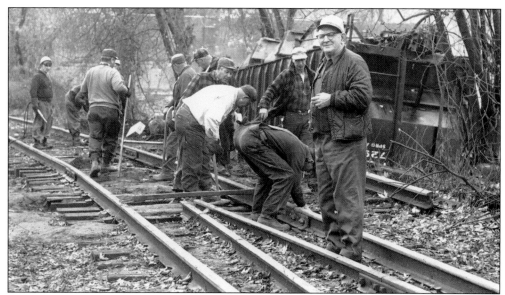

A crew of track workers (also known as gandy-dancers) is repairing a section of track following a derailment. Fuller A. Dibble stands looking at the camera. He was an engineer surveying the progress. He does not appear to be camera shy. A gauge bar is lying across the track, near the center of the photograph. It was used to accurately measure the proper distance between the rails, insuring a smooth and safe ride. (Photograph by Robert Haines.)

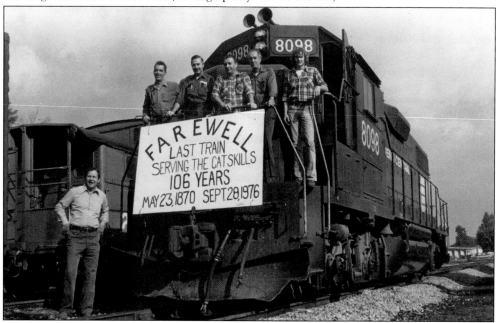

The year 1976 does not seem that long ago; nevertheless, it signaled the end of an era and lifestyle. This is a timeless photograph in that its subject and message is universal. Robbie Ryder, in the flannel shirt, is standing on the right. Ironically, it was his first day on the job (as a brakeman), coinciding with the last day of operations on the Catskill Mountain Branch. The rest of the men are the train crew. Robbie Ryder is still a railroad man, employed as an Amtrak engineer today (2011). (Photograph by Robert Haines.)

More often than not, derailments happen at inopportune moments. When heavy equipment is available and the site accessible, the job becomes a bit less difficult. Here, a truck is about to be wheeled in place under a boxcar, as it is being hoisted by a crane. Bob Haines would come out to photograph things as they happened; oftentimes, he would provide the railroad with documentation of the accident. (Photograph by Robert Haines.)

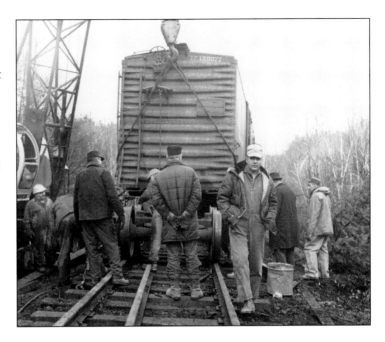

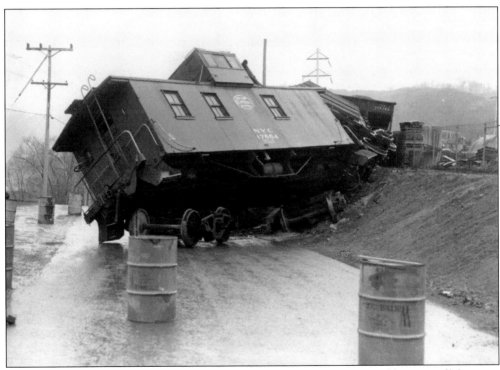

There were several factories just north of Kingston Point. They were served by spurs off the main line, which ran from Kingston Point to the Rondout yard. This derailment occurred at the Hudson Cement Company near Kingston Point. Hudson Cement was a natural and durable cement, similar to the famous Rosendale Cement. (Photograph by Robert Haines.)

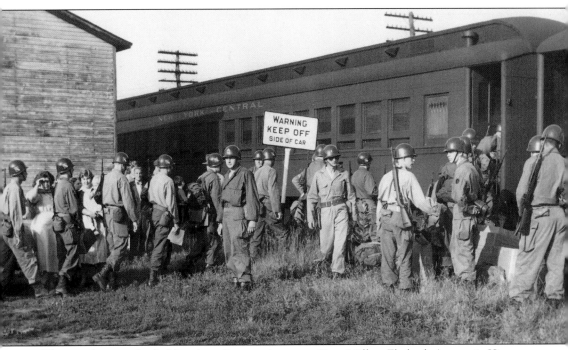

This is a photograph of soldiers boarding a train next to Deyo Mill on Flatbush Avenue in Kingston in 1951, during the Cold War era. They may have been on their way to the Korean Conflict. (Courtesy of Robert Haines.)

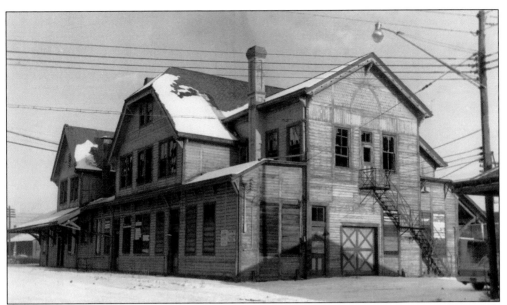

Bob Haines took this photograph of the abandoned Kingston Station around 1970. (Photograph by Robert Haines.)

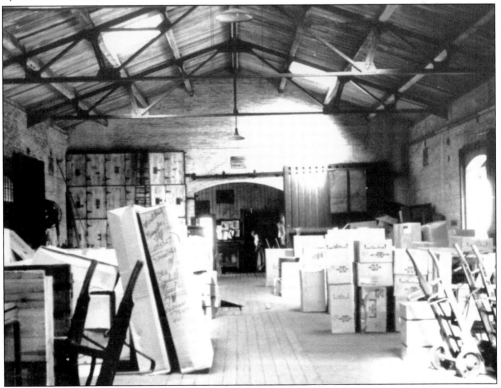

Shown here is the interior of the Kingston freight house around 1950. By the late 1950s, the trucking industry was replacing the railroad as a major freight carrier in many market situations. Smaller cities, such as Kingston, ceased to be important hubs of railroad activity. (Photograph by Robert Haines.)

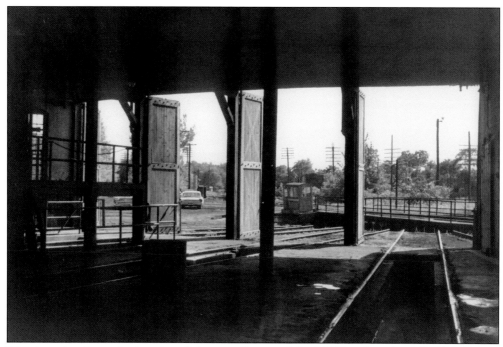

This is a view from the interior of the roundhouse of the U&D rail yard on the Rondout in Kingston. Essential for the efficient operation of the roundhouse is a turntable, just beyond the doors. (Courtesy of Robert Haines.)

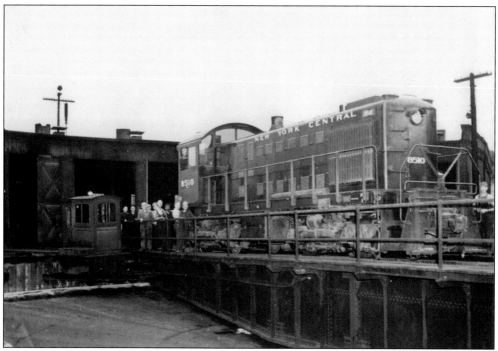

This is the turntable and roundhouse in the Rondout yard in Kingston, New York. Sitting on the turntable is the first diesel locomotive assigned to Kingston. (Photograph by Robert Haines.)

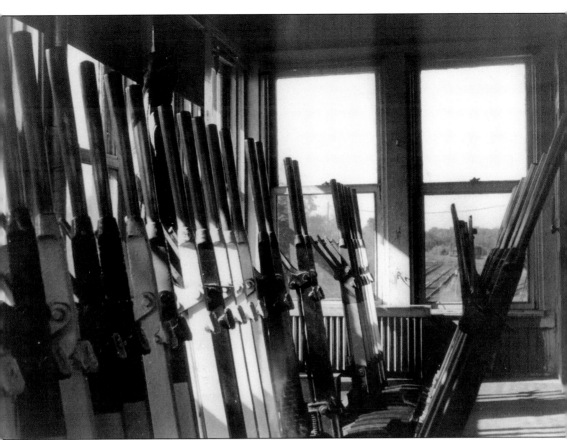

This is an interior view of the switching tower in the Kingston rail yard. There was no reliance on electricity or electronic monitoring of rail traffic in the rail yard. The operator had to continually survey the yard visually and manually throw the proper switches at just the right time. A network of interlocking rods, levers, and bell cranks allowed him to accomplish his tasks from his bird's nest perch. The photograph was taken in 1960. (Photograph by Robert Haines.)

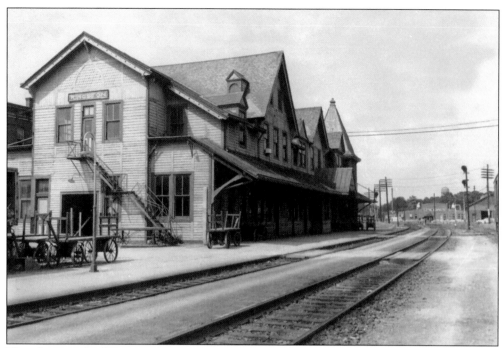

This photograph of Kingston Union Station dates from the early 20th century. There is much to be admired in the architecture of this bygone era. (Photograph by Robert Haines.)

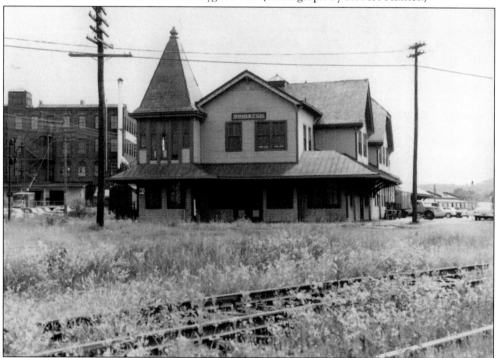

In this 1955 photograph of the north side of the Kingston Union Station, the decline is evident. The growth of weeds around the tracks forecasts the imminent demise of the railroad. (Photograph by Robert Haines.)

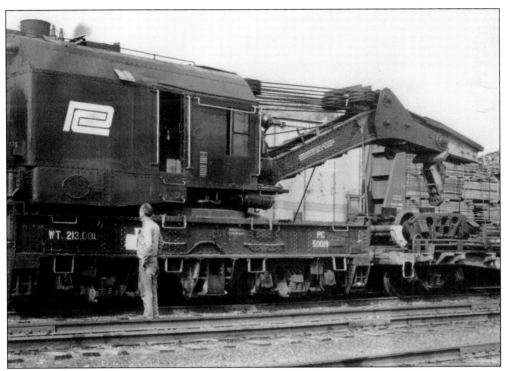

Railroad cranes are wonderful machines that fascinate many, especially children. This crane, owned by the Penn Central Railroad, is in transit through the yard in Kingston. (Photograph by Robert Haines.)

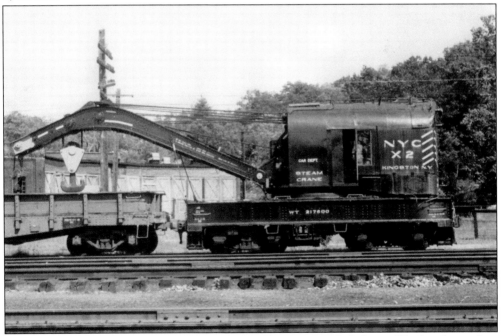

This is a photograph of an old steam crane, owned by the New York Central Railroad, traveling through the Kingston yard. (Photograph by Robert Haines.)

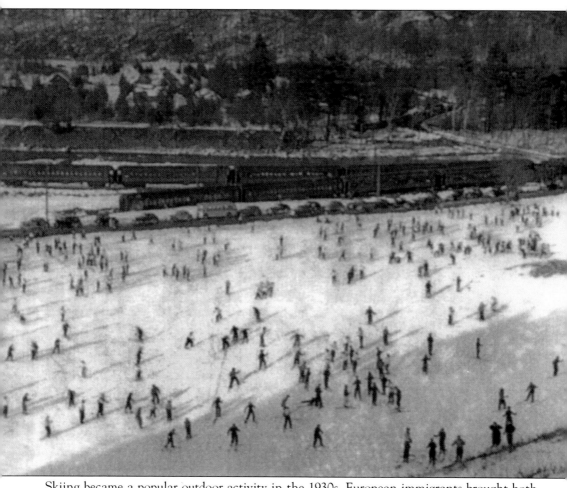

Skiing became a popular outdoor activity in the 1930s. European immigrants brought both Nordic and Alpine techniques to many places across the United States. The Winter Olympic Games in Lake Placid, New York, in 1932 created an audience and participants for the sport in upstate New York. This is the Simpson Ski Slope, sometime in the 1940s. A train was chartered to serve both as transportation for the skiers and overnight accommodations for them. Cars and buses are parked adjacent to the railroad tracks. This was not a regular station stop. It is west of Phoenicia, known as Snyder Hollow. (Courtesy Lonnie Gale.)

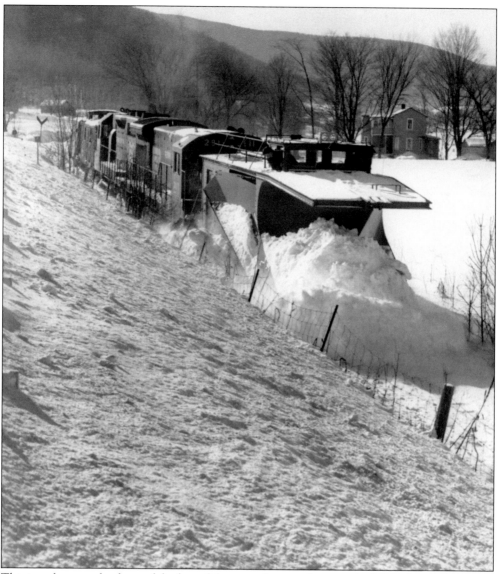

This is a photograph of one of the last of the snowplows working on the U&D during the winter of 1975, near Kelley's Farm. (Photograph by Robert Haines.)

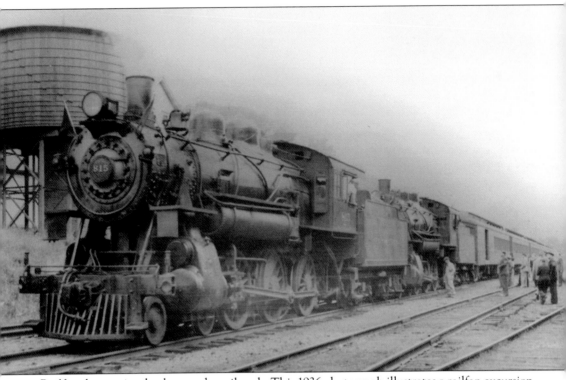
Railfans have existed as long as the railroads. This 1936 photograph illustrates a railfan excursion train on the Ulster & Delaware at Arkville. (Photograph by Robert Haines.)

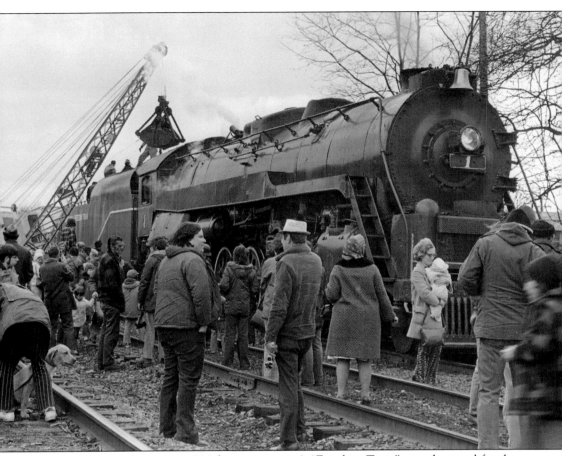

The year 1976 was the nation's 200th anniversary. A "Freedom Train" was chartered for the occasion. Here, it is being greeted by residents of Kingston as it takes on coal. (Photograph by Robert Haines.)

The Ulster & Delaware line was a stepchild of the New York Central. Older equipment was recycled from other lines for use on the U&D. (Photograph by Robert Haines.)

Two

THE CENTRAL NEW ENGLAND RAILWAY

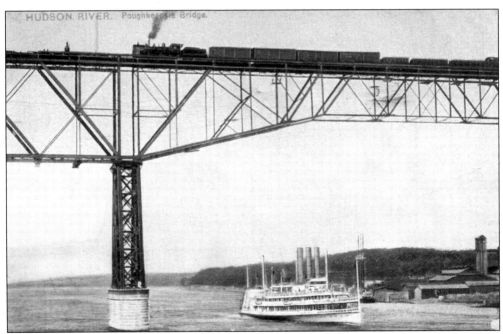

The Poughkeepsie Railroad Bridge was an engineering marvel of its time. Unfortunately, the trestle was so high above the Hudson River where both east shore and west shore railroads crossed, no rail connections were possible. Eventually, the bridge lost its commercial usefulness as alternate river crossings, albeit longer, were employed. In this image, a steam engine is crossing, going west, while a day liner underneath is going south. (Courtesy of Elizabeth Werlau.)

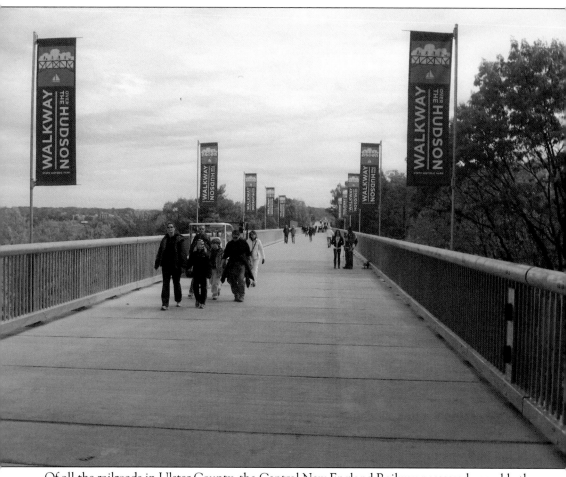

Of all the railroads in Ulster County, the Central New England Railway possessed arguably the most outstanding man-made feature: the Poughkeepsie Railroad Bridge, which spanned the Hudson River. It was an engineering marvel of its time. Abandoned in 1983, it has now been reborn as the Walkway Over the Hudson, a New York State park. (Courtesy of Marty Lennox.)

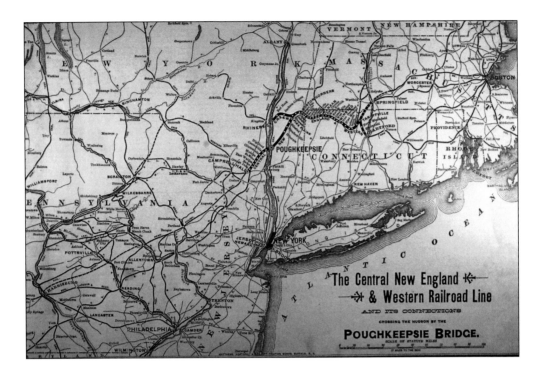

These maps, dated October 1889, show the new connections made by the Poughkeepsie Railroad Bridge. (Courtesy of Carlton Mabee.)

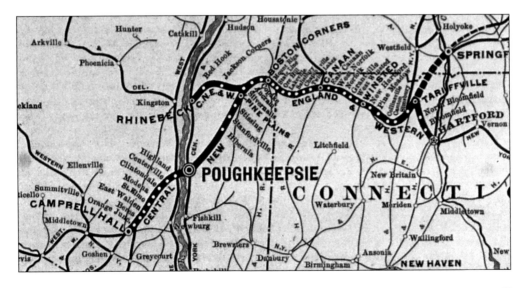

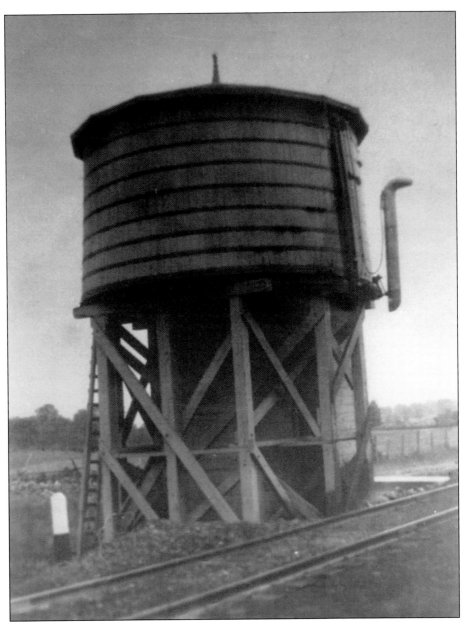

The water tank is stationed in the Modena Station yard. Back in the days of the steam engine, water was an essential commodity for the engine. An ample supply of water was required. Several factors influenced how many miles an engine could go with its original tank of water on any given run, including distance traveled, grade (pitch of any given section of track), and the weight of the train. Several other factors had to be considered, such as availability of the water, quality of the water, and whether the tank could be filled by using gravity or whether the water had to be pumped. The tank itself was usually made of wood (white pine, cedar, or redwood), resting upon a foundation of masonry. The tanks held 20,000–40,000 gallons of water. Typically, the tank was 16 feet in diameter and 16 feet high. This tank had a capacity for 65,000 gallons. This water tank in Modena obtained its water from Cole's Pond (now called Lembo Lake by the locals), which was the irrigation source for an apple orchard. (Courtesy of Shirley V. Anson.)

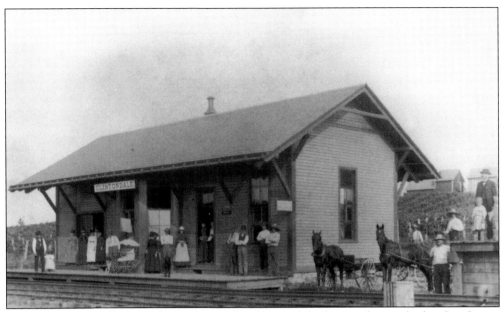

This is a photograph, from about 1891, of the Clintondale Station during the height of train travel. Standing on the far left on the station platform is Daniel John Donaldson and next to him is his granddaughter Ida Hazel Deyo. The Deyo family members were early settlers in the area surrounding New Paltz. (Courtesy of Shirley V. Anson.)

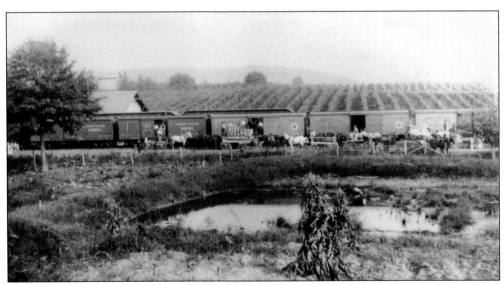

A freight train is pulling into the Clintondale Station; its roof is barely visible on the left. It has stopped to load grapes to be shipped into the New York City area. The grape vineyard in the background was owned by Daniel Donaldson, who was pictured with his granddaughter in the previous photograph. This land is currently owned by David Roehrs. The farm in the background is part of the Apple Greens Golf Course. This postcard is dated around 1891. (Courtesy of Shirley V. Anson.)

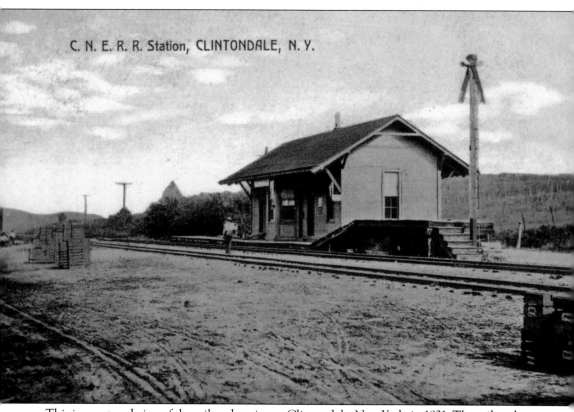

C. N. E. R. R. Station, CLINTONDALE, N. Y.

This is a postcard view of the railroad station at Clintondale, New York, in 1931. The railroad was owned at this time by the New York, New Haven & Hartford Railroad (successor to the Central New England Railway). The station burned down in 1965. (Courtesy of Shirley V. Anson.)

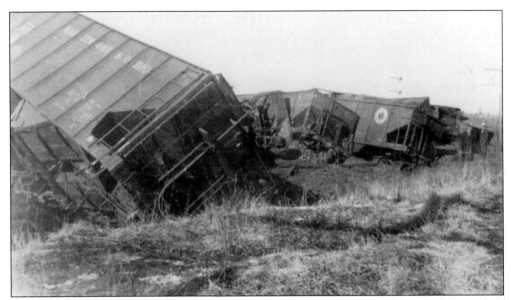

On March 5, 1936, a Central New England train was traveling east from Maybrook, just north of the Clintondale Station, to New Haven, Connecticut, when the last portion of the train jumped the tracks, ripping up the eastbound tracks for about 400 yards. (Photograph by Anthony Palazzo Sr.; courtesy of Shirley V. Anson.)

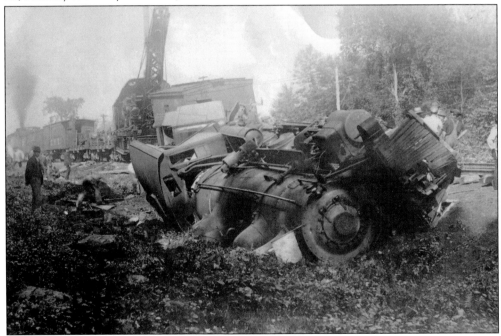

A steam engine derailed and tipped over on its side in Loyd on September 18, 1907. Engineer Bill Prince was killed in the wreck. The train was traveling eastbound from Maybrook, New York, to Hopewell Junction, New York, when it crashed. The cause of the crash could not be established. A large crane (also known as a big hook) was brought from Maybrook to clear the track. A work train is in the background on the left. It was brought to the scene so that the cars could be put back on the track. (Courtesy of Shirley V. Anson.)

This view of Weed's Mill Pond (before the Central New England railroad tracks were relocated) shows the railroad track and the trolley line in front of the gristmill (in the center of the photograph). Careful examination of the picture shows the gristmill with a sign indicating that the building belongs to A.H. Weed Feed and Grain. The railroad tracks, the trolley tracks, and the road are between the pond and the gristmill. When the track was realigned, it crossed through the millpond. The realignment changed the flow rate of the stream. There was no longer enough waterpower to adequately serve the gristmill and lumber mill. (Courtesy of Estelle and Thurlow Weed Jr.)

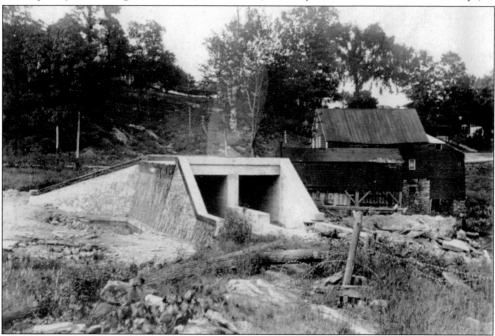

In this 1922 postcard, the Central New England Railway decided to move its track along a more favorable grade. The picture above, taken from the Weed's Mill Vineyard, shows the new culvert. The culvert opening on the right was for Black Creek to pass through; the opening on the left side of the culvert served pedestrian and vehicular traffic. The long, low building (the sawmill) and taller building (the gristmill) are behind the culvert on the right. (Courtesy of Estelle and Thurlow Weed Jr.)

This 1922 photograph shows the new track in place. The trolley line track is visible in the foreground. (Courtesy Estelle and Thurlow Weed Jr.)

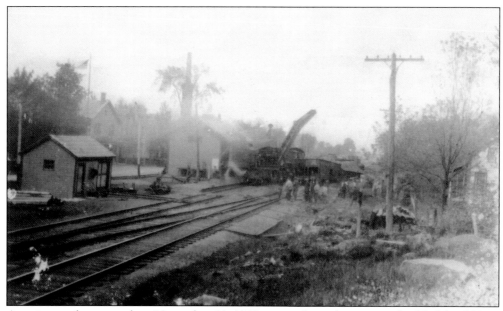

A train wreck occurred on November 14, 1919, across from the present-day Highland Hose Company No. 2 firehouse. (Courtesy of Town of Lloyd Historical Collection.)

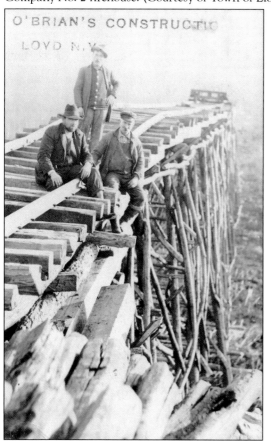

This is a postcard view of the construction of the trestle at Brook's Crossing over the Central New England Railway tracks. The historic spelling for Loyd has only one L, and the modern spelling for the township of Lloyd has two L's. Vivian Yess Wadlin explains: "Loyd was located at the intersection of Pancake Hollow Road and Old New Paltz Road. That whole section along Old New Paltz Road is spelled that way (Loyd) in all the postcards I have in my collection. The sign on the gate of the cemetery on Old New Paltz Road still reads, 'Loyd Cemetery.'" (Courtesy of Vivian Yess Wadlin.)

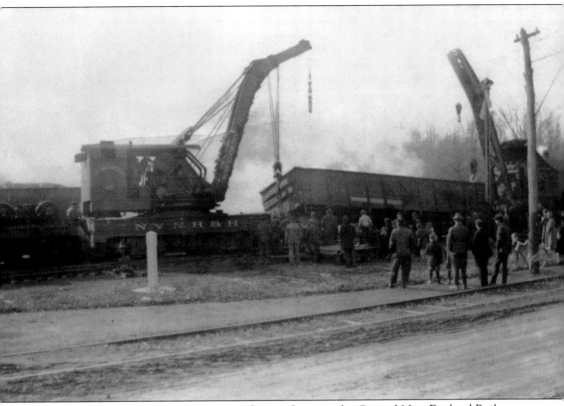

Pictured are two railroad cranes removing the wreckage on the Central New England Railway track on November 15, 1919, from a site adjacent to Station No. 2 of the Highland Hose Company. The tracks in the foreground are trolley tracks between New Paltz and Highland. (Courtesy of Town of Lloyd Historical Collection.)

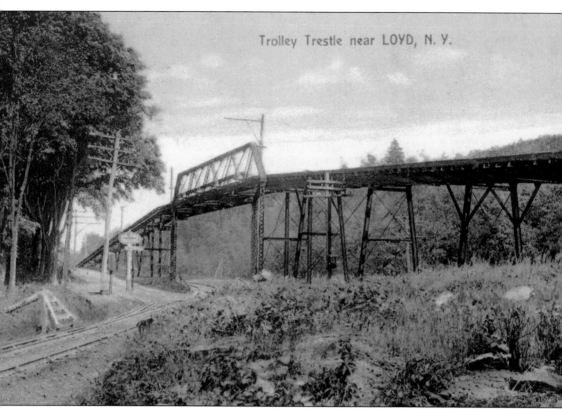

Trolley Trestle near LOYD, N. Y.

This postcard shows the completed trolley trestle at Brook's Crossing over the Central New England tracks with the local road, the New Paltz Turnpike, on the left. Most railroads did not allow trolley tracks to cross their tracks at grade level, whenever possible. This was a safety measure to prevent an uninvited trolley traveling on a railroad right-of-way. In Pennsylvania, the early hub of railroad activity, trolley tracks were gauged (the distance between the rails) differently from the standard gauge of the railroad. This ensured that a trolley would never end up (mistakenly misguided) on to a railroad line. In the transportation museum world, any trolley acquired from a Pennsylvania line has to have another set of trucks substituted so that it could ride on standard-gauge railroad tracks. (Courtesy of Vivian Yess Wadlin.)

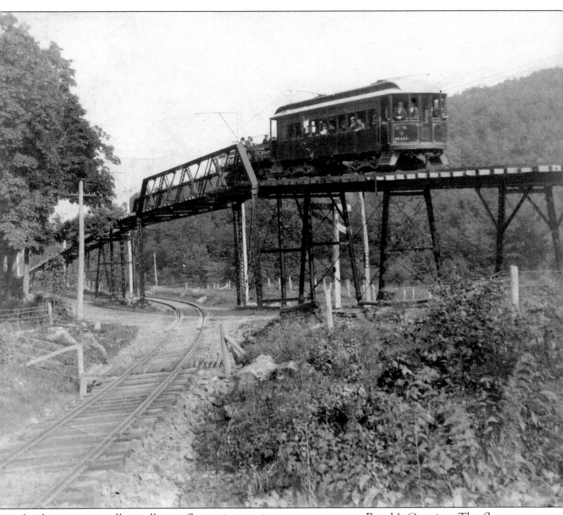

In this view, a trolley pulling a flatcar is carrying passengers over Brook's Crossing. The flatcar was used when the freight engine could not handle all the freight that was off-loaded from the West Shore Railroad. The trestle was used because the Central New England Railway would not allow the trolley to cross the railroad tracks at grade level. The trolley operated between New Paltz and Highland from 1897 to 1925. (Courtesy of Town of Lloyd Historical Collection.)

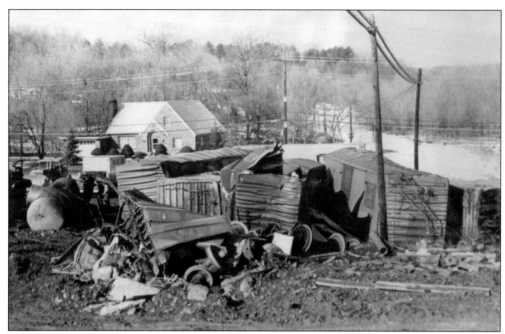

At approximately noon on Tuesday, January 28, 1969, a Penn Central train traveling from Maybrook to New Haven was slowing down before it went onto the Poughkeepsie Railroad Bridge. (Photograph by Frank Lombardi.)

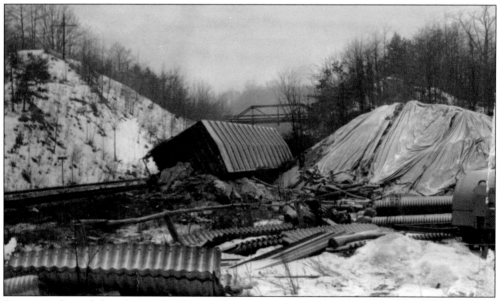

Reports indicated that during the slowing-down process near the Lloyd (Highland) Town Barn, the rear portion of the train failed to respond to the braking action. The couplers between two of the cars buckled, causing one of the cars to go off the track. The other cars in the rear of the train continued at a high rate of speed, causing the cars to jump the tracks and fill up the ravine through which the train was passing. The above photograph is of the wrecked cars in the ravine. (Photograph by Frank Lombardi.)

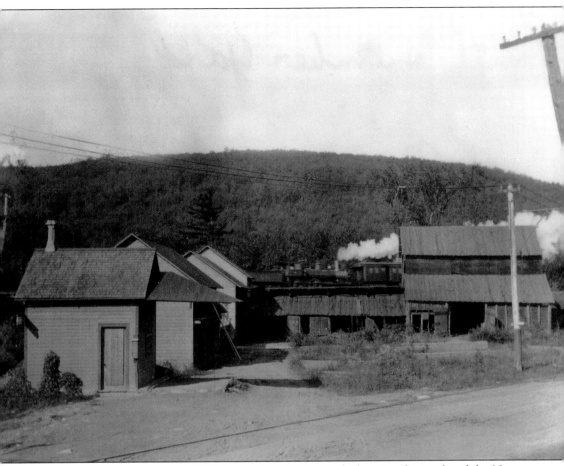

This is an early photograph of G.W. Pratt's first lumberyard, showing the tracks of the New Paltz–Highland trolley line in the foreground. In the background, a steam engine from the Central New England Railway can be seen pulling what appears to be a passenger train. At this point, the two lines are close enough and at the same grade to permit the exchange of trolley cars from the trolley line to the Central New England Railway tracks. This was done to permit the conveyance of travelers across the Poughkeepsie Railroad Bridge. The consist then proceeded to the Highland Station and across the Poughkeepsie Railroad Bridge to the Central New England Station at Parker Avenue on the Poughkeepsie side. (Courtesy of Town of Lloyd Historical Collection.)

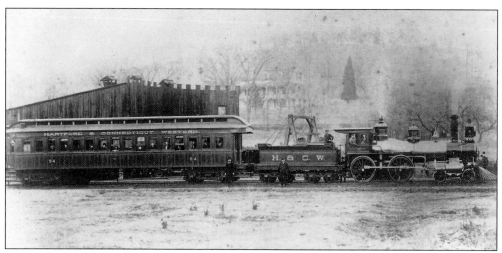

This is a photograph of the second train that was dispatched on Saturday, December 29, 1888, to cross the newly constructed railroad bridge, which spanned the Hudson from Poughkeepsie to Highland. The steam engine and passenger car made another successful crossing; the train was greeted by residents of Highland. (Courtesy of Elizabeth Werlau.)

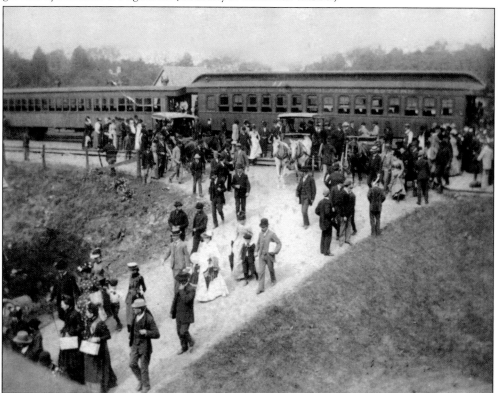

On Monday, January 1, 1889, a Hartford, Connecticut & Western engine is pulling two passenger cars for the first official trip across the Poughkeepsie Railroad Bridge. The stop was made just west of the G.W. Pratt & Sons Lumber Company, before reaching the Johnston Coal Company. The Highland Railroad Station had not yet been built at that time. (Courtesy of Austin T. McEntee Collection and Town of Lloyd Historical Collection.)

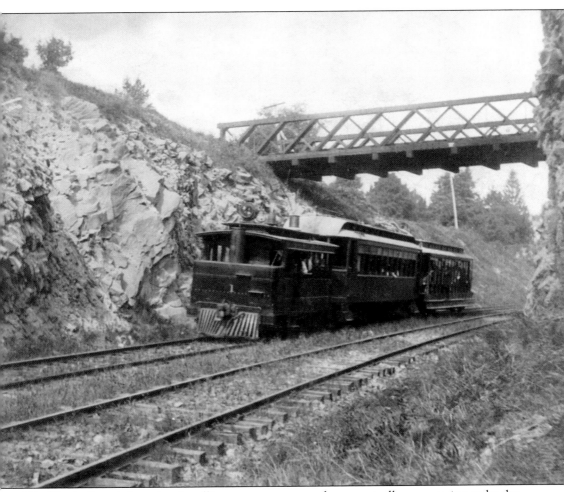

The "Dinky," a switch engine, is pulling a passenger car and an open trolley car, passing under the Route 9W overpass in Highland. An interchange between the railroad (the Philadelphia, Reading & New England, also known as the Central New England) and the New Paltz–Highland trolley line was located at Pratt's Mill (approximately a mile and a half west of this location). The first trip took place on August 13, 1897. This interchange was continued until February 1904, when the service was discontinued. The New Paltz–Highland trolley line continued to run until July 6, 1925. (Courtesy of Town of Lloyd Historical Collection.)

CENTRAL NEW ENGLAND RAILWAY,
Poughkeepsie Bridge Route.

RAPID TRANSIT TIME TABLE,
IN CONNECTION WITH THE

New Paltz and Poughkeepsie Traction Co.,
Effective, June 3rd, 1900.

Rapid Transit Trains between POUGHKEEPSIE, HIGHLAND and NEW PALTZ.

Trains for Highland and New Paltz Daily, except Saturday and Sunday.			Trains for Highland & Poughkeepsie Daily, except Saturday and Sunday.		
Trains Leave Poughkeepsie.	Arrive Highland.	Arrive New Paltz.	Trains Leave New Paltz.	Leave Highland.	Arrive Poughkeepsie.
7.25 A.M.	7.33 A.M.	8 15 A.M.	7.10 A.M.	7.45 A.M.	7.55 A.M.
8.30 "	8.45 "			9.10 "	9.25 "
9.10 "	9 18 "	10 00 "	9 00 "	9.33 "	9.43 "
10.15 "	10 23 "	11.00 "		9.34 "	9.52 "
11.25 "	11.40 "		10.00 "	10.35 "	10.45 "
12 00 M.	12 08 P.M.	12.45 P.M.	11.45 "	12 20 P.M.	12.30 P.M.
1.15 P.M.	1.23 "	2.00 "		12.01 "	12 20 "
2 15 "	2.23 "	3 00 "	1 00 P.M.	1.35 "	1.45 "
3 15 "	3.23 "	4 00 "	2.00 "	2.35 "	2.45 "
4.15 "	4.23 "	5.00 "	3.00 "	3.35 "	3.45 "
5.08 "	5 16 "	6.00 "	4.00 "	4.35 "	4.45 "
5.13 "	5.28 "		5.00 "	5 35 "	5 45 "
6.15 "	6.23 "	7.00 "	6.00 "	6 35 "	6.45 "
7.45 "	7.53 "	8.30 "	7 30 "	8.05 "	8 15 "

Saturday and Sunday only.			Saturday and Sunday only.		
Trains Leave Poughkeepsie.	Arrive Highland.	Arrive New Paltz.	Trains Leave New Paltz.	Leave Highland.	Arrive Poughkeepsie.
†7.25 A M.	†7.33 A.M.	†8.15 A.M.	†7.10 A.M.	†7.45 A.M.	†7 55 A.M.
†8.30 "	†8.45 "			†9 10 "	†9 25 "
9.10 "	9 18 "	10 00 "	9.00 "	9 33 "	9 43 "
10 15 "	10.23 "	11.00 "		9.34 "	†9.52 "
†11.25 "	†11.40 "		10 00 "	10 35 "	†10.45 "
12.00 M.	12.08 P.M.	12.45 P.M.		†12.01 P.M.	†12 20 P.M.
1.15 P.M.	1.23 "	2.00 "	11.45 "	12.20 "	12 30 "
2.00 "	2.08 "	2.55 "	1.00 P.M.	1 35 "	1.45 "
2.45 "	2.53 "	3.40 "	1.35 "	2 20 "	2 30 "
3.30 "	3.34 "	4.25 "	2.15 "	3 05 "	3.15 "
4.15 "	4.23 "	5 00 "	3.05 "	3 50 "	4.00 "
5.00 "	5.08 "	5.55 "	3 50 "	4.35 "	4 45 "
†5.13 "	†5.28 "		4.35 "	5.20 "	5.30 "
5.40 "	5.48 "	6 40 "	5.15 "	6 00 "	6.10 "
6.30 "	6.38 "	7 25 "	6 05 "	6.50 "	7.00 "
7.15 "	7.23 "	8.00 "	6.50 "	7 35 "	7.45 "
8.15 "	8.23 "	9.00 "	8 00 "	8.35 "	8 45 "
†Saturday only.			†Saturday only.		

Rates of Fare.—Fare between Poughkeepsie and Highland or Pratts Mills, 10 cents. Excursion tickets, 15 cents. Package of ten tickets, 75 cents. Between Poughkeepsie and Centreville, 15 cents. Between Poughkeepsie and Loyds, 15 cents. Between Poughkeepsie and Ohioville, 20 cents. Between Poughkeepsie and New Paltz, 25 cents. Excursion, 40 cents.

Passengers from New Paltz and stations on the Electric road paying fare to Poughkeepsie, will be furnished by the conductor a ticket good for the ride from Pratts Mills to Poughkeepsie on the C. N. E. Ry.

Purchase Tickets at Office.— Double Fare will be charged if paid on Trains between Poughkeepsie, Highland and Pratts Mills, and conductor will issue to such passengers Duplex Train Tickets.

W. J. MARTIN, Sup't C. N. E. Ry.

This timetable (June 3, 1900), which covers the Poughkeepsie–Highland–New Paltz line, shows the departure and arrival times and fares to travel from Poughkeepsie to Highland and Highland to New Paltz. Travelers going to Highland could take the Central New England train from the Parker Avenue Station in Poughkeepsie to either the Highland Station near G.W. Pratt's Lumber Company or Pratt's Mills. Passengers going on to New Paltz would transfer to the New Paltz–Highland trolley. (Courtesy of Town of Lloyd Historical Collection.)

This is an artist's conception of a futuristic monorail at the intersection of Milton and Vineyard Avenues in Highland. The monorail is headed from Highland toward the Hudson River. The postcard is postmarked October 1908. During this period, an interurban trolley was running between Highland and New Paltz (from 1897 to 1925), a distance of approximately 10 miles. (Courtesy of Elizabeth Werlau.)

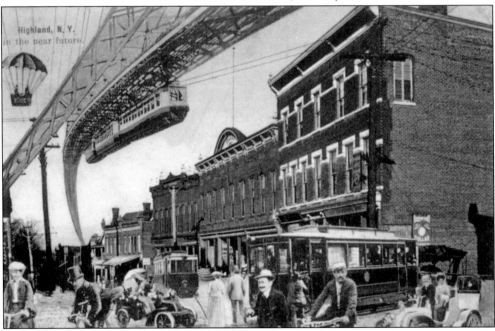

Highland, N. Y.
in the near future.

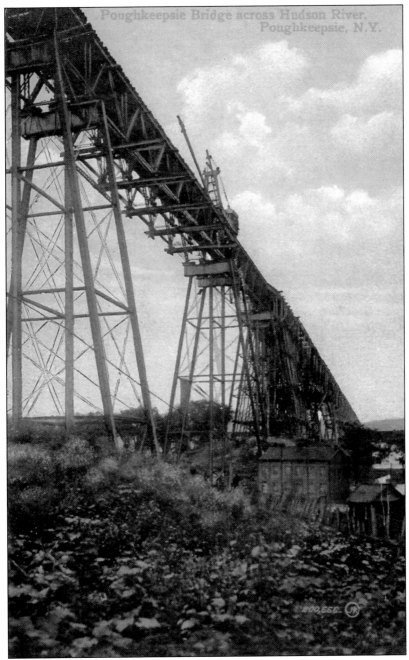

The Poughkeepsie Railroad Bridge was an engineering and construction marvel of its time. It was a cantilevered structure and was simultaneously built from both sides of the Hudson River. After the superstructure was completed, the crane that was used to maneuver the various sections of the bridge in place was moved off the bridge. The distance from the first pier on the east side of the Hudson River to the last pier on the Highland side of the river was 6,756 feet. The highest point on the bridge to the surface of the river was 212 feet. The cornerstone for the bridge was laid in 1873, but there was no further construction until September 1886. The cost of the bridge at that time was $3.5 million. (Courtesy of Elizabeth Werlau.)

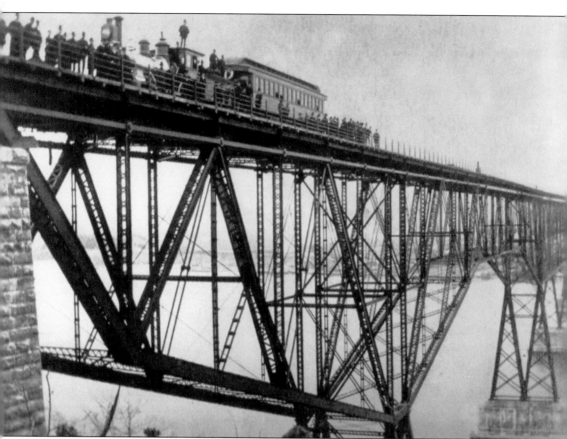

On Saturday afternoon, December 29, 1888 (at about 3:00 p.m.), a locomotive from the Hartford, Connecticut & Western Railroad, with one passenger car attached, slowly crossed the newly completed bridge. The train stopped near the end of the bridge on the Highland side. A number of Highland residents marched out to the train and climbed on board the passenger car. Included among the group of esteemed local residents were Captain Bowen, Philip Wilklow, Jared Thompson, H.C. Tilson, and A.W. Williams. In the modern era of liability insurance and lawsuits, this sort of public enthusiasm is frowned upon. (Courtesy of Elizabeth Werlau.)

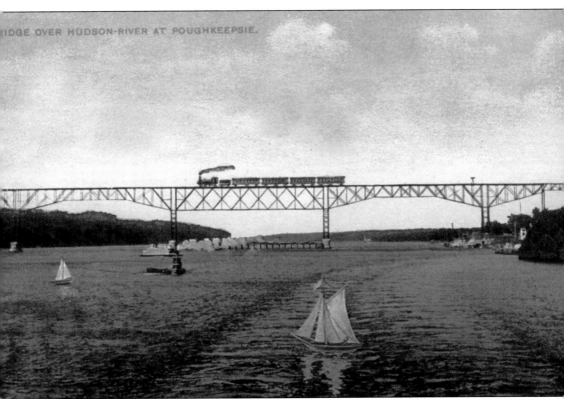

This is a 1909 postcard view of a steam engine pulling a passenger train, while passing over the Poughkeepsie Railroad Bridge to Highland, New York. While the hand-painted postcard was based on a photograph, it could almost be an idealized view of the Hudson River painted by an artist of the time. Directly under the bridge is a barge loaded with a cargo of ice. There were many icehouses along the Hudson River storing ice that was cut from the frozen river during the winter months. Much of the ice was sent to New York City. (Courtesy of Vivian Yess Wadlin.)

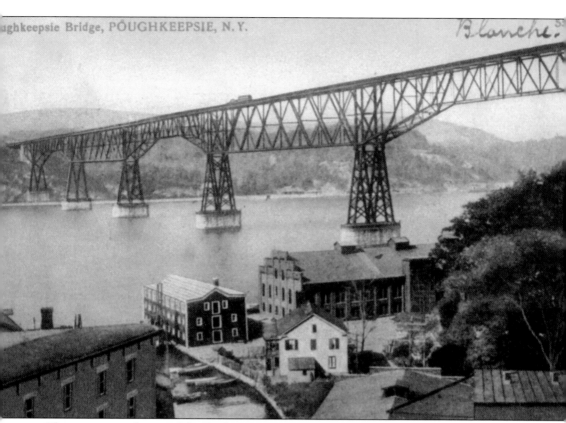

This is a postcard view of the Dinky steam engine pulling the trolley across the Poughkeepsie Railroad Bridge toward Highland. (Courtesy of Vivian Yess Wadlin.)

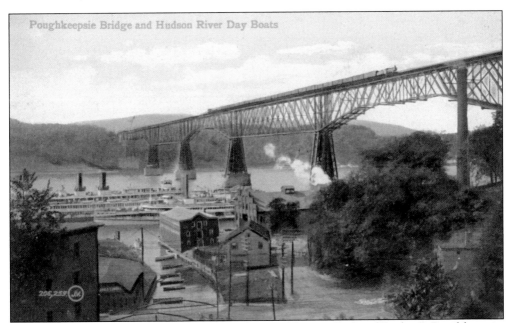

This postcard depicts a freight train crossing the Poughkeepsie Railroad Bridge to Poughkeepsie. In the foreground on the river, two day liners wait at the Poughkeepsie docking area. (Courtesy of Town of Lloyd Historical Collection.)

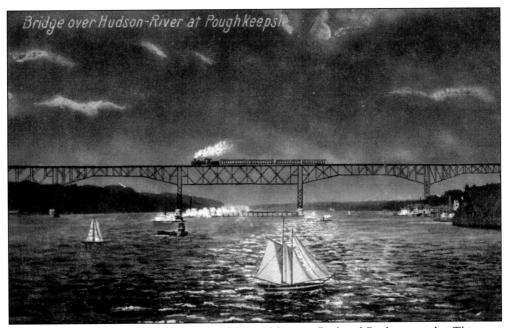

A steam engine is pulling a train across the Poughkeepsie Railroad Bridge at night. This very same postcard has also been rendered as a daylight scene. (Courtesy of Vivian Yess Wadlin.)

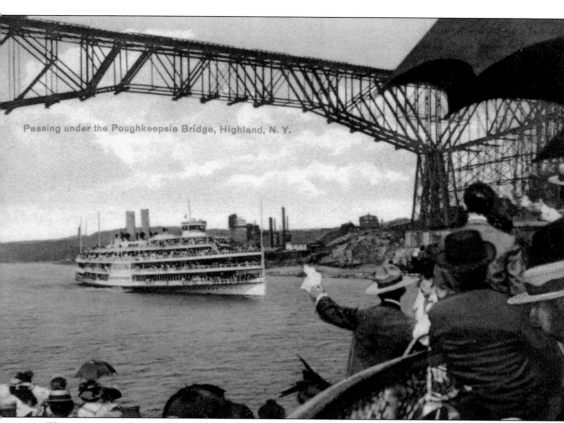

Passing under the Poughkeepsie Bridge, Highland, N. Y.

This is a view of one of the Hudson River day liners passing under the Poughkeepsie Railroad Bridge. The day liners carried passengers and sightseers, ceasing operations in the early 1970s. Coauthor Steve Ladin recalls a trip he made with his parents and sister sometime in the late 1950s: "We boarded from a pier on the Hudson in lower Manhattan. I still have a picture in my mind of passing the 'mothball fleet' [from World War II] anchored near Haverstraw. The boat continued up the Hudson. We disembarked at West Point and toured the Military Academy until the boat returned in mid-afternoon. It had sailed up as far as Poughkeepsie, turned around and returned to pick up the passengers at West Point for the ride home." (Courtesy of Vivian Yess Wadlin.)

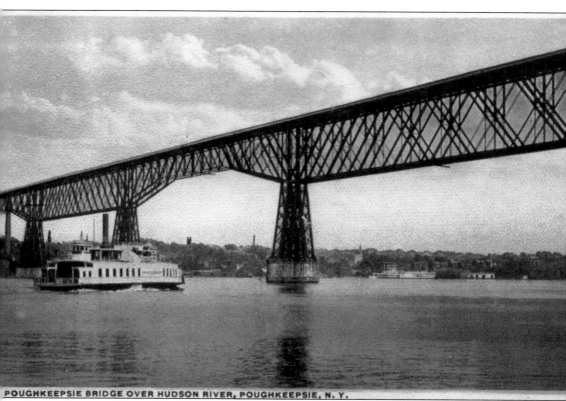

POUGHKEEPSIE BRIDGE OVER HUDSON RIVER, POUGHKEEPSIE, N. Y.

In this postcard view, the ferryboat *Brinckerhoff* is passing under the Poughkeepsie Railroad Bridge on its way to Highland from Poughkeepsie. The ferry provided passenger service between Ulster and Dutchess Counties until December 31, 1941. The Mid-Hudson Bridge, serving automobile traffic, opened in 1931. The cessation of ferry service 10 years later, in 1941, was caused by gas rationing, as a result of United States' entry into World War II. The reinstatement of modern ferry service is currently being studied along a number of north-south routes and east-west crossings, including Poughkeepsie to Kingston. (Courtesy of Town of Lloyd Historical Collection.)

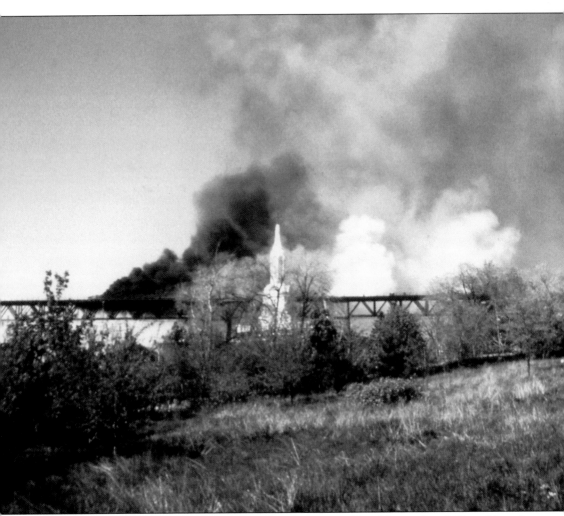

The Poughkeepsie Railroad Bridge is in flames at the eastern (Poughkeepsie) end. The white spire of the Mount Carmel Church in Poughkeepsie is visible in the center of the photograph. On May 8, 1974, sparks, generated by a freight train heading east on the Poughkeepsie Railroad Bridge, were the probable cause of the fire. The Penn Central Railroad, owner of the bridge, opted not to repair the bridge. Alternate, longer routes were used in place of the Poughkeepsie Bridge Hudson River crossing. The bridge remained derelict until 2009, when it reopened as the pedestrian Walkway Over the Hudson. (Photograph by Austin McEntee, courtesy of Carleton Mabee.)

Three

THE ONTARIO & WESTERN RAILWAY

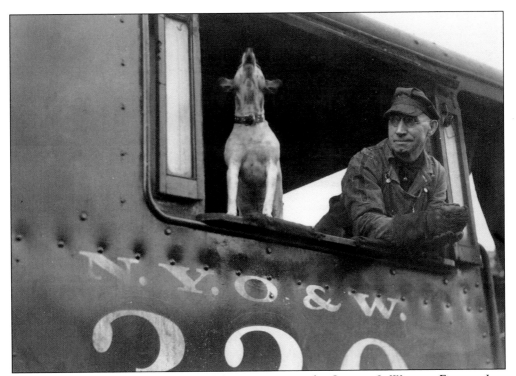

This photograph dates near the end of the steam era on the Ontario & Western. Fireman Lou Crawford is taking a break from shoveling coal in to locomotive No. 320. Assistant fireman Spike is accompanying the blowing steam whistle with a song of his own. (Courtesy of Robert Haines.)

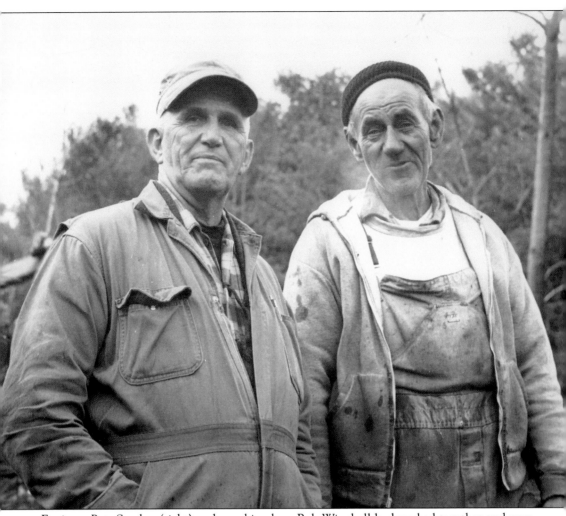

Engineer Pete Sember (right) and wrecking boss Bob Winchell had worked together and were friends for over 40 years at the time of this photograph, dated December 10, 1972. Their friendship was borne out of working during the steam era, which had effectively ended by the time the photograph was taken. (Courtesy of Robert Haines.)

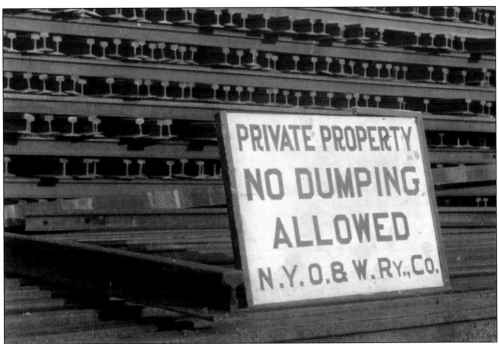

This picture was taken sometime in 1960 by a young Robert Haines. The rails were taken up from the (then defunct) Ontario & Western (O&W) Kingston Branch. They were stored in Kingston in a yard located near what is now known as Schwenk Drive. Haines's father worked for the New York Central Railroad. He prohibited Bob, who was in his late teens, from "collecting" the sign. Someone else collected the sign. It now resides in a private collection somewhere in Pennsylvania. (Photograph by Robert Haines.)

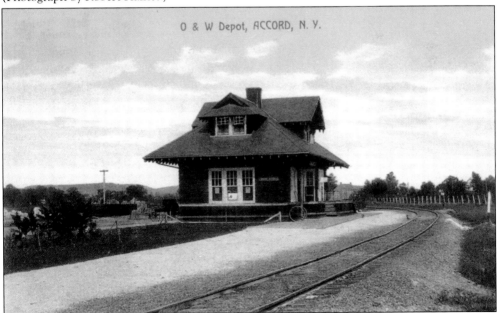

This is a bucolic summer scene of the Accord depot during the era before passenger service ended. (Courtesy of Vivian Yess Wadlin.)

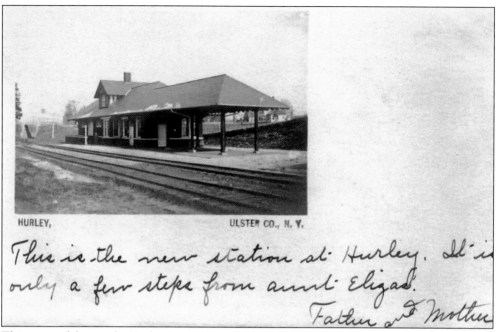

HURLEY, ULSTER CO., N. Y.

This is the new station at Hurley. It is only a few steps from aunt Eliza's.

Father and Mother

This postcard depicts the Hurley Station just after it had been constructed around 1902. (Courtesy of Town of Hurley Historian.)

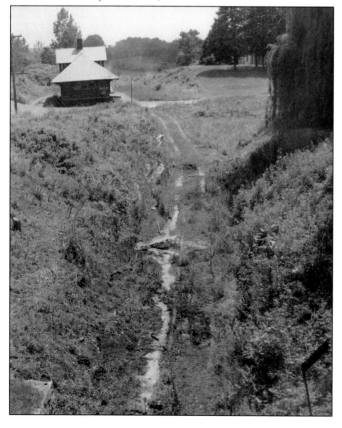

The tracks and the ties have been removed, and there is no evidence of any ballast remaining on the right-of-way near the Hurley Station. Even though this day during the summer of 1960 is bright and sunny, there is a feeling of abandonment. This right-of-way is now an extremely popular rail trail. (Courtesy of Robert Haines.)

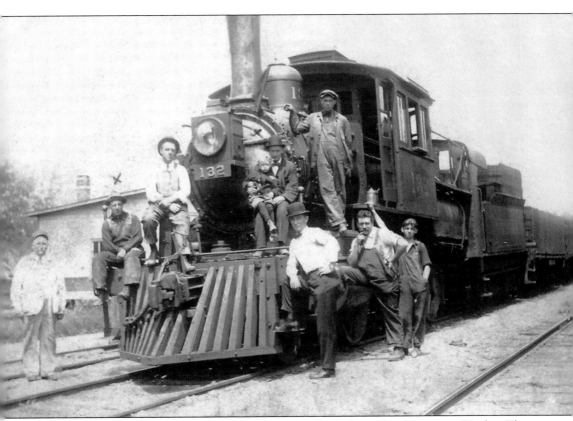

This is a view of O&W engine No. 132 pulling what looks like a freight train in Hurley. The authors have not been able to identify the train crew, but there is a future railfan and or employee sitting on his father's or perhaps his uncle's lap. (Courtesy of Town of Hurley Historian.)

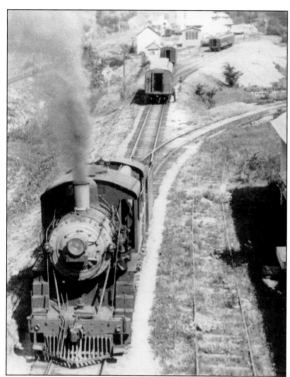

This is a view of the O&W yard in Kingston, looking east from the Washington Avenue Viaduct. It was taken by Henry P. Eighmey in 1932. The Ulster & Delaware tracks are visible, cutting across the upper-left corner of the photograph. The activity pictured is the switching out of cars for the return to Middletown in Orange County. (Courtesy of Robert Haines.)

The NW2 switch engines pictured below were acquired from the O&W by the New York Central Railroad in 1957. The location is at the West Shore interchange in Kingston. The engines are on their way to the roundhouse at Cornell Street and Smith Avenue to be inspected for use over the entire New York Central system. The tracks in the picture were part of the former Ulster & Delaware Railroad Catskill Mountain Branch. (Courtesy of Robert Haines.)

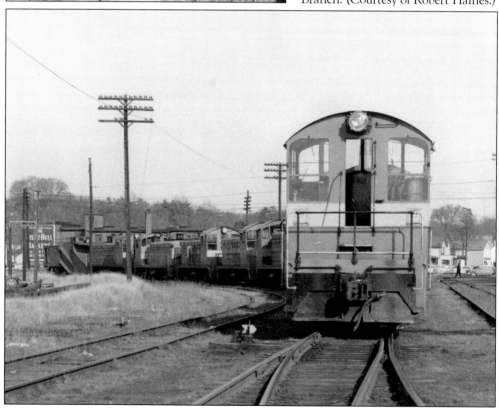

Four

THE ULSTER & DELAWARE RAILROAD

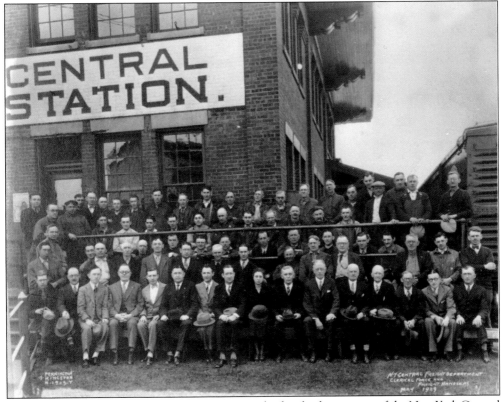

This group photograph was shot in May 1929. It is the freight department of the New York Central in Kingston, New York. Of course, there were no women freight handlers at this time, and only one woman appears sitting among the clerical staff. (Courtesy of Robert Haines.)

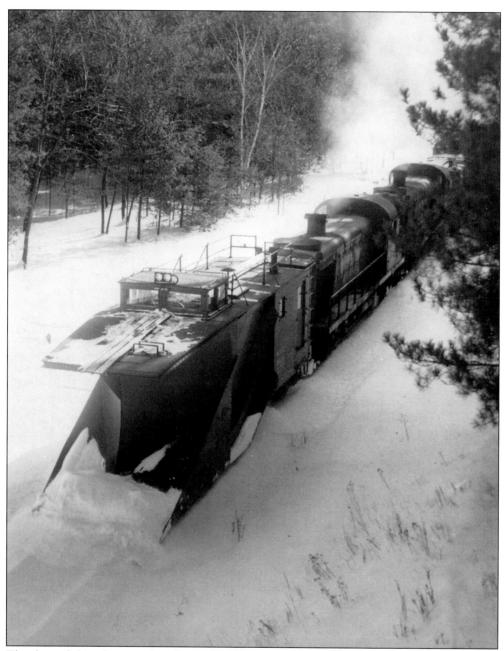

The date of this photograph is December 30, 1967, only a few years before the cessation of operations on the Catskill Mountain Branch of the New York Central. It is near Boiceville, close to the western border of Ulster County. Even with no passenger service and dwindling freight traffic, the tracks were still cleared of snow. It appears that several switch engines are providing the push on the snowplow. (Courtesy of Robert Haines.)

This is a historic map of the Ulster & Delaware Railroad. (Courtesy of Trolley Museum of New York.)

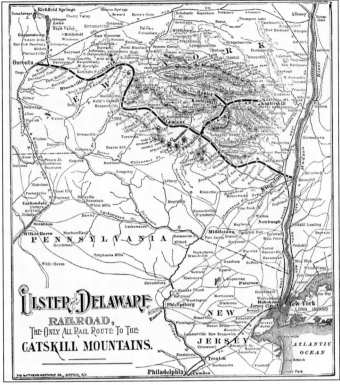

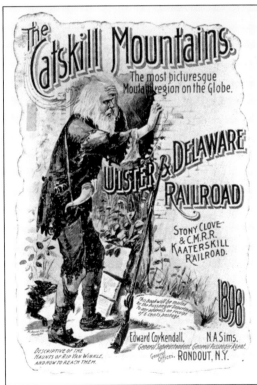

This is the cover for an advertising booklet promoting tourism in the Catskill Mountains. At this time, the United States had become a major industrial power with a booming economy that allowed a new middle and upper class to take vacations. The railroads, in addition to carrying freight, began to court this new segment of the population, who had a comfortable income and leisure time. So-called mountain houses proliferated in the Catskills and other places throughout Ulster County. (Courtesy of Lonnie Gale.)

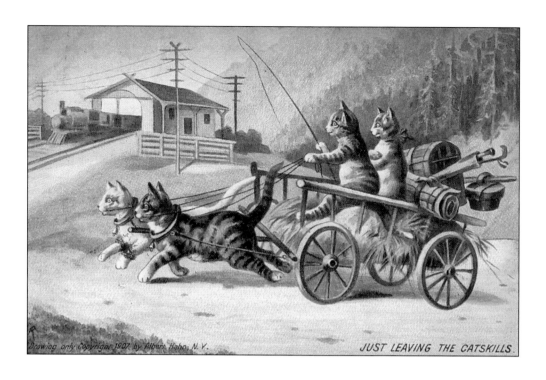

This postcard (front and back) is dated August 16, 1908, and was probably written by a young man on vacation in the Catskills. The image of two cats was often used as a graphic symbol for the Catskill Mountains. (Courtesy of Lonnie Gale.)

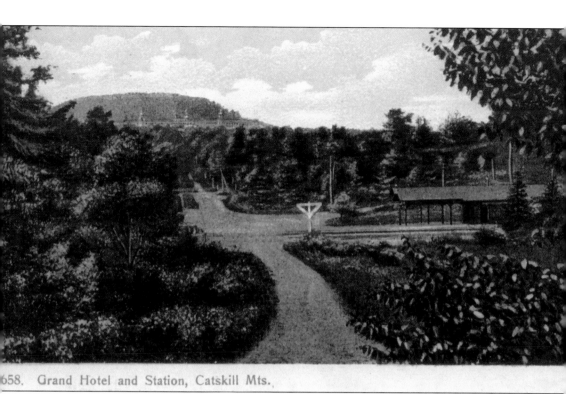

658. Grand Hotel and Station, Catskill Mts.

This is a view of the Grand Hotel Station on the Ulster & Delaware Railroad with the Grand Hotel in the distant background in Highmount. The postcard is postmarked July 28, 1906. (Courtesy of Vivian Yess Wadlin.)

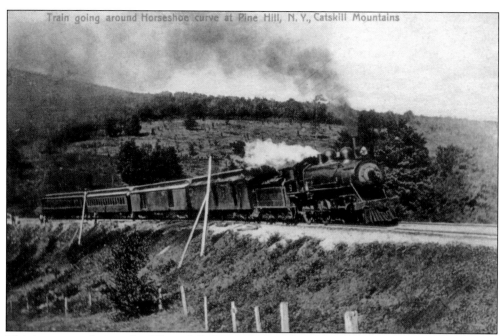

This is a postcard view of an Ulster & Delaware Railroad passenger train rounding the horseshoe curve at Pine Hill, New York. While this horseshoe curve is not a large one, it is a feature—along with bridges, tunnels, and aqueducts—that railroads fans will go to extraordinary lengths to see, and better yet, to experience. (Courtesy of Vivian Yess Wadlin.)

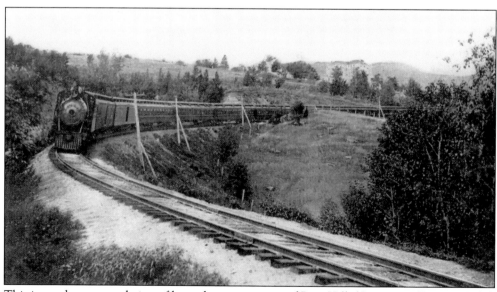

This is another postcard view of horseshoe curve, west of Pine Hill. (Courtesy of Lonnie Gale.)

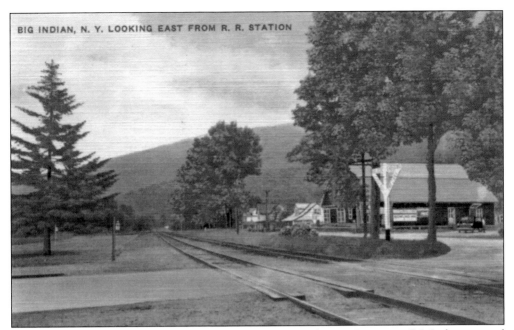

This is a postcard view looking east from the Ulster & Delaware Station in Big Indian around 1940. The red building with the green roof on the right was Bryant's Store. It is now gone. It was a general country store and had a bowling alley on the second floor. The white house just to the left still stands today. It was located one or two doors down from the Big Indian firehouse. (Courtesy of Vivian Yess Wadlin.)

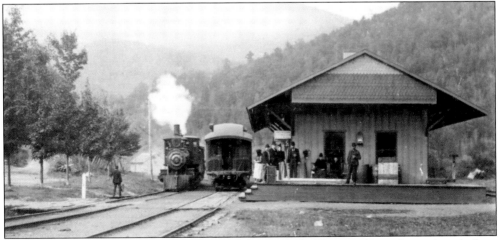

This is the Big Indian Station in the heart of the Catskills. The people on the station platform are dressed rather formally, as was customary of the times. (Courtesy of Robert Haines.)

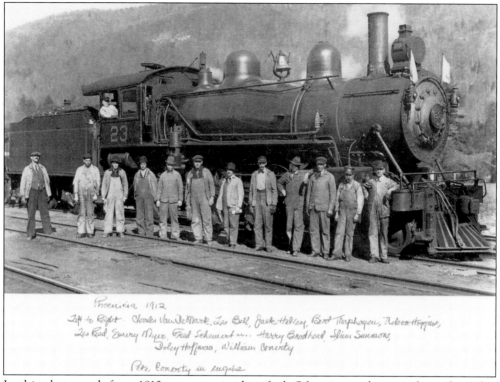

Phoenicia 1912
Left to Right Charles VanDeMark, Les Bell, Jack Halsey, Bert Traphagen, Nelson Hoppin,
2nd Row, Emery Myer, Fred Scheuert... Harry Brodhead, Slim Simmons,
Doley Hoffman, William Conerty
Pete Conerty in engine

In this photograph from 1912, everyone is identified. Oftentimes, photographs such as this commemorated a special occasion or event. Engine No. 23 looks awfully good. Perhaps this was the day that it was inaugurated into service. It is obvious that the men took pride in their work. Despite their work clothes becoming heavily soiled from coal and oil, many of them came to work wearing ties. Charles Van De Mark, standing slightly apart on the left, was a trainman. Les Reed, standing sixth from the left, started as a fireman, became an engineer, and was killed in Glenford in 1930 when a locomotive exploded. He was the granduncle of Robert Haines. (Courtesy of Robert Haines.)

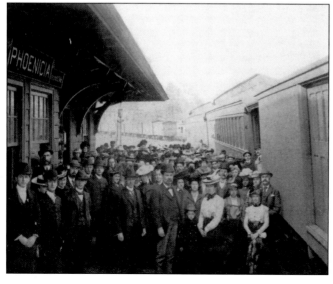

This is a photograph, taken around 1910, of an ordinary transportation day at the Phoenicia Station. During the peak year of 1923, trains carried over 670,000 passengers on the Delaware & Hudson Catskill Mountain line. (Courtesy of Lonnie Gale.)

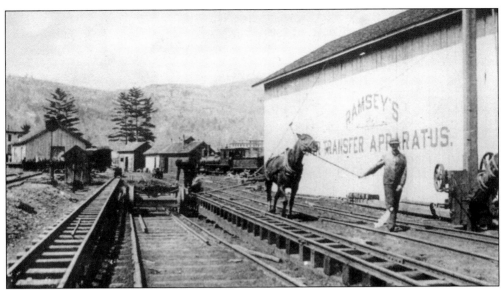

A Ramsey Car Transfer Apparatus was employed in Phoenicia to change out the trucks from the main line standard gauge to the narrow gauge of the Stony Clove Branch. A car was rolled over a pit and suspended to allow one set of trucks to be rolled out from underneath and exchanged for another set. The narrow-gauge tracks of the Stony Clove Branch ran between the standard gauge in the pit, allowing the transfer to take place. Once the operation was completed, the car was ready to be pulled up the steep grade to the Catskill Mountain House on North Lake in Green County. (Courtesy of Robert Haines.)

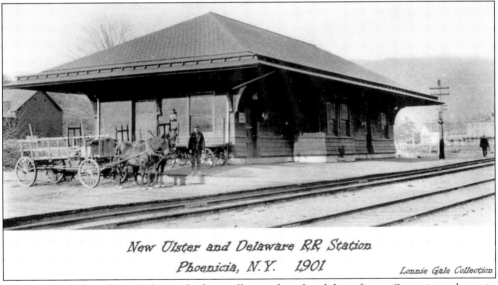

New Ulster and Delaware RR Station
Phoenicia, N.Y. 1901
Lonnie Gale Collection

There was a daily milk train that picked up milk cans from local dairy farms. Sometimes the train would not stop; it slowed down enough so that empty cans could be off-loaded as the full ones were handed on board. The milk cars were transferred to the West Shore Railroad at Kingston. A fresh shipment arrived in Weehawken, New Jersey, each morning for processing. The milk was loaded onto milk wagons, which were driven onto a ferry-barge that crossed the Hudson River. Fresh milk reached markets all around Manhattan on the day following its departure from the Catskill dairy farms. (Courtesy of Lonnie Gale.)

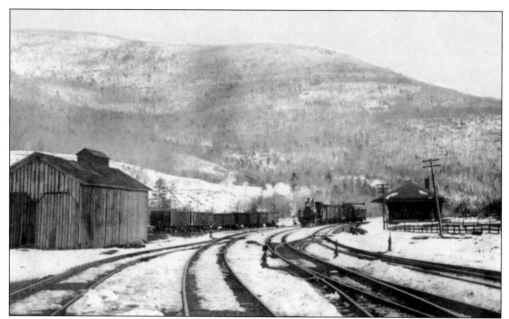

This is a beautiful Catskill winter scene at Phoenicia looking east. The Catskills are now a state park, and development of the lands is tightly regulated by New York State. A major landholder is the New York City Department of Environmental Protection, the agency charged with supplying New York City with drinking water. (Courtesy of Lonnie Gale.)

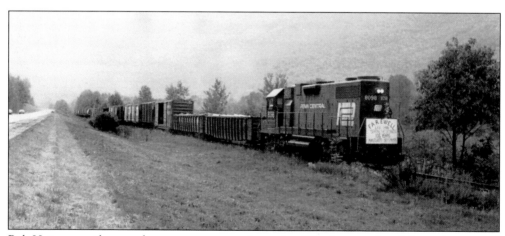

Bob Haines was there to document many anniversaries. His photographs of the retirements of workers, engines, and entire railroad lines have a poignancy about them. This photograph documents the last eastbound train in October 1976. It is composed of 36 cars and is leaving Phoenicia. It was collecting empty freight cars from the soon-to-be abandoned railroad line. The two gondola cars were carrying the last load of timber out of the Catskill forest from Fleischmanns in Delaware County. On the left of the picture is Route 28. (Photograph by Robert Haines.)

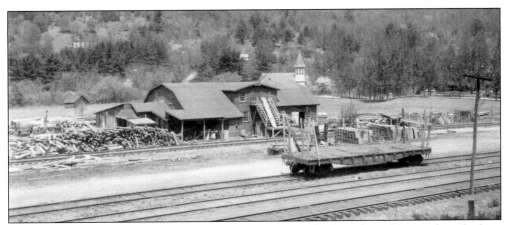

The building pictured was a lumber mill, located conveniently along the rail line and not far from the source of the raw material. (Courtesy of Lonnie Gale.)

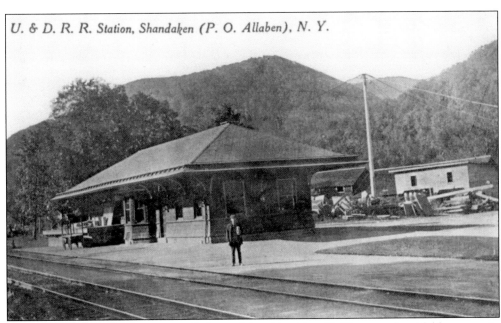

U. & D. R. R. Station, Shandaken (P. O. Allaben), N. Y.

The Catskill Mountains were ruggedly beautiful and inviting. Unlike more formidable mountain ranges, they were more accessible and, as a result, became a popular vacation destination. The vernacular architecture of the stations continues to be admired to this day. Just to the right of the station, in the rear of the picture, is what old-timers refer to as a gin pole. Guy wires kept it vertical. A hand-cranked gearing mechanism mounted on the pole and a pulley system mounted on the spar (a section of it is visible as a horizontal element near the ground on the right side of the picture) allows a worker to hoist up heavy objects from delivery wagons, rotate the spar, and off-load the cargo in the yard. (Courtesy of Lonnie Gale.)

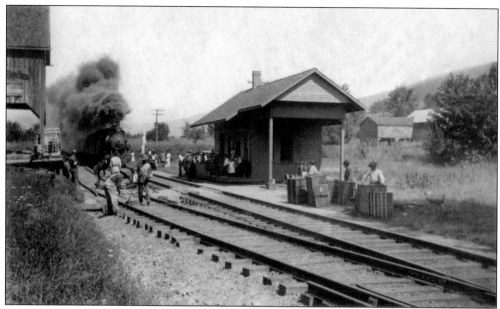

An Ulster & Delaware train is approaching the Boiceville Station about 1900. Because of the imminent flooding due to the construction of the Ashokan Reservoir, the station was torn down in 1912. (Courtesy of Lonnie Gale.)

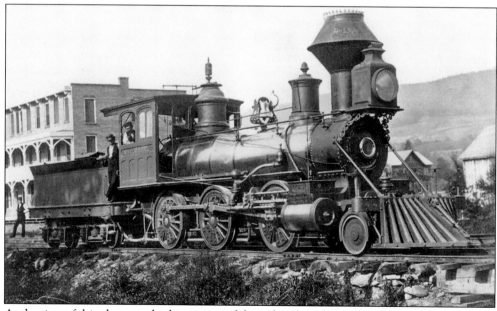

At the time of this photograph, this section of the railroad was known as the Rondout & Oswego Line. The steam engine *William C. Moore* is posing in West Shokan. This area is now under water, part of the Ashokan Reservoir. The building in the back is the Hamilton House Hotel. (Courtesy of Lonnie Gale.)

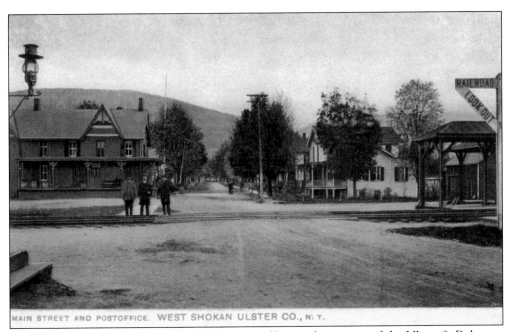

MAIN STREET AND POSTOFFICE. WEST SHOKAN ULSTER CO., N. Y.

This is a postcard view of Main Street, the post office, and a portion of the Ulster & Delaware Railroad Station in West Shokan, Ulster County, New York. (Courtesy of Vivian Yess Wadlin.)

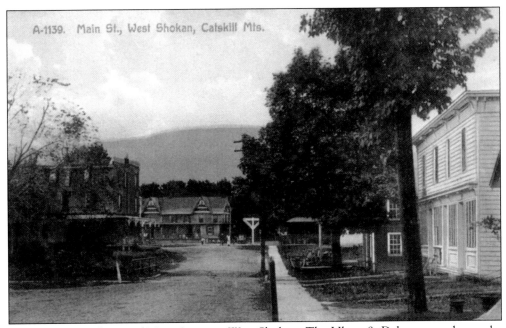

A-1139. Main St., West Shokan, Catskill Mts.

This is a postcard view of Main Street in West Shokan. The Ulster & Delaware tracks can be seen in the distance, crossing Main Street. (Courtesy of Vivian Yess Wadlin.)

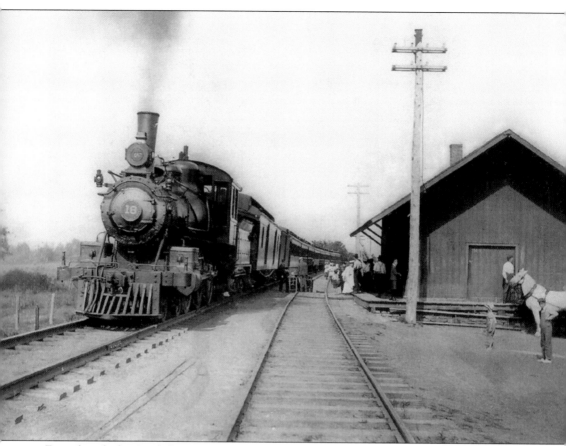

Even though the Catskill Mountain line was not a major line, there was much passenger traffic, especially during the summer months. Vacation destinations in the Catskills became more accessible as a result of the railroad. This is the Olive Branch Station, another casualty of the Ashokan Reservoir. (Courtesy of Lonnie Gale.)

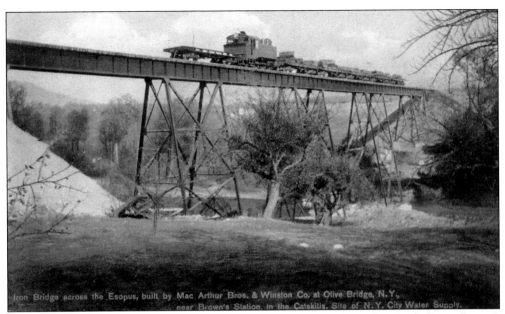

Iron Bridge across the Esopus, built by Mac Arthur Bros. & Winston Co. at Olive Bridge, N.Y., near Brown's Station, in the Catskills. Site of N. Y. City Water Supply.

This is a postcard view of the iron bridge across the Esopus Creek at Olive Bridge, near Brown's Station. A work train is crossing the bridge. This bridge was constructed to facilitate the building of the Ashokan Reservoir. As the reservoir was completed, the bridge structure was removed. Historian Lonnie Gale comments that the iron bridge and track leading to it were built to facilitate the construction of the reservoir prior to the relocation of the U&D track. During the construction, as many as 30 locomotives were employed to complete the project. (Courtesy of Vivian Yess Wadlin.)

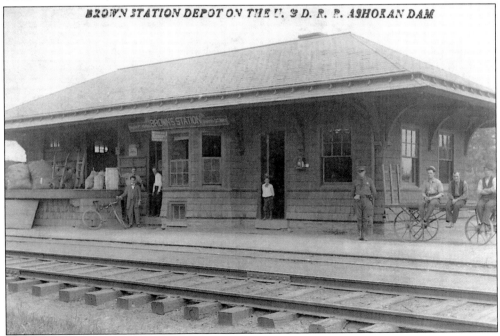

This example of Ulster & Delaware Railroad architecture became a casualty of the flooding caused by the construction of the Ashokan Reservoir. (Courtesy of Lonnie Gale.)

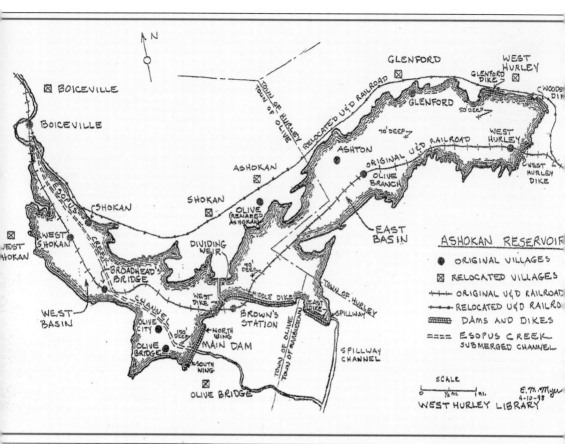

The map above is a composite, drawn by Dakin Morehouse. It shows the original locations of the track and the submerged villages resulting from the construction of the Ashokan Reservoir. (Courtesy of Dakin Morehouse and the Empire State Railroad Museum.)

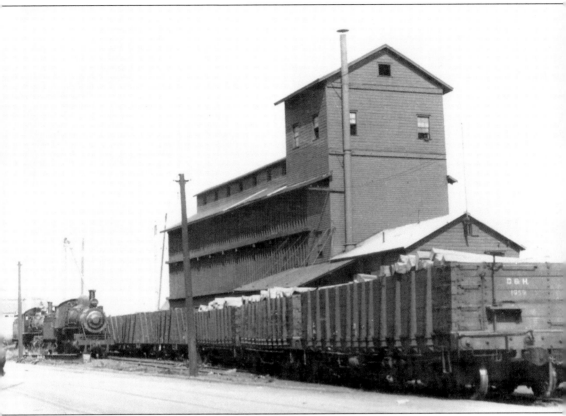

This building housed coal pockets for the Cornell Steamship Company. The gondola cars are loaded with timber, possibly railroad ties. The boys dressed in knickers on the left side of the photograph indicate a date from around the 1920s. (Courtesy of Lonnie Gale.)

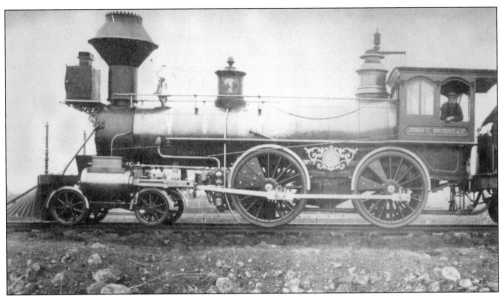

This is an early photograph of the Rondout & Oswego engine, *John C. Broadhead.* The headlight arrangement is typical of the times. Oil was used for illumination until the development of electricity and generators came into use. (Courtesy of Lonnie Gale.)

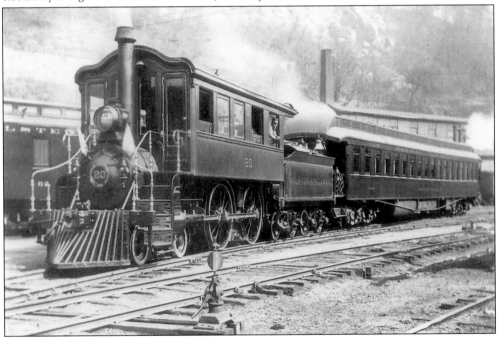

The above photograph is of the inspection engine of Samuel Decker Coykendall, the Ulster & Delaware Railroad president. The railroad board members would ride in the extended cab of the locomotive for trips to inspect the line and railroad operations. The cab was furnished with wicker seats, polished brass railings, and mahogany trim. This is the Rondout rail yard. The rail yard is now the home of the Trolley Museum of New York, which runs an excursion trolley between Kingston's Rondout waterfront and Kingston Point on the Hudson River. (Courtesy of Robert Haines.)

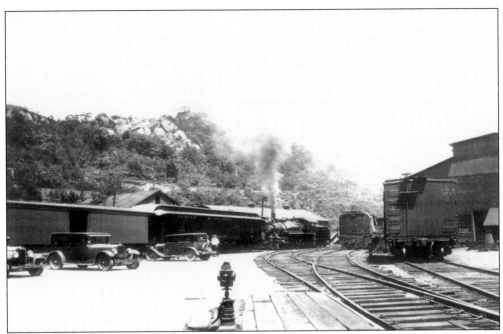

This is another early scene of the rail yard in the Rondout section of Kingston. The hills in the background were home to cement mines and kilns; there was a network of tunnels that ran under and climbed the hill serving the mines. The photograph is dated sometime in the early 1930s. (Courtesy of Lonnie Gale.)

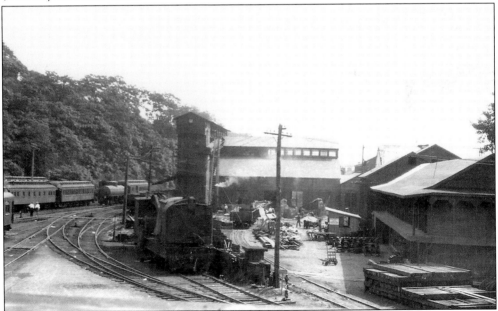

Kingston was the center of much commerce until the 1950s. The demand for bluestone, natural cement, and coal declined. Local industries, despite offering a superior product, could not compete with international conglomerates. With the advent of alternate modes of transportation, including the trucking industry, the railroads carried fewer and fewer passengers and freight. This photograph is dated in the late 1920s. (Courtesy of Lonnie Gale.)

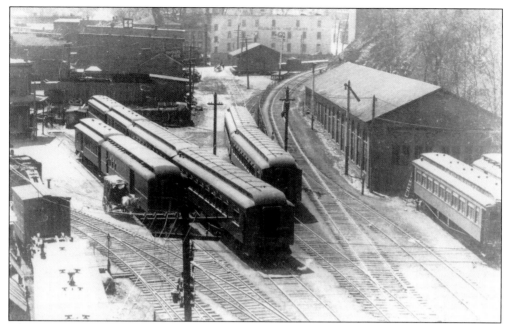

This is a view of the Rondout rail yard coach storage area, taken from the coal pocket looking west. A new structure constructed on the foundation of the building on the right now houses the Trolley Museum of New York. (Courtesy of Robert Haines.)

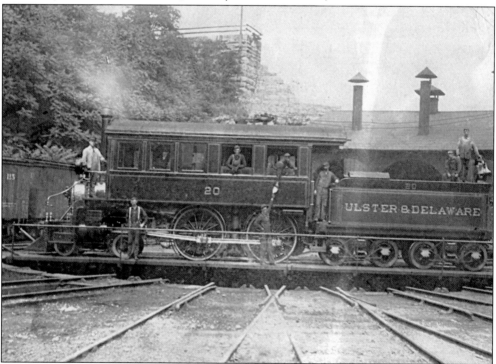

This is a special photograph showing the president's inspection engine on the turntable in the Rondout yard. Carved into the hill on the left is part of the Newark Lime and Cement mine. (Courtesy of Robert Haines.)

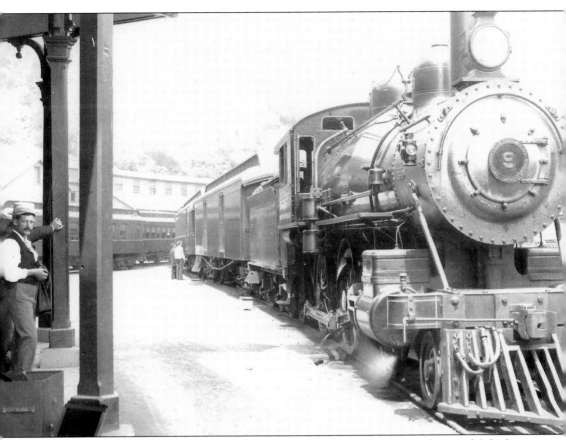

This engine looks as if it has just received a cleaning and a paint job at the Rondout yard. It looks to be pulling a baggage car and at least one coach. (Courtesy of Robert Haines.)

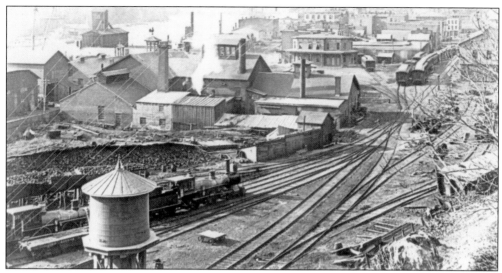

This is a view of the busy Ulster & Delaware rail yard in the Rondout district of Kingston. Part of this site is now occupied by the Trolley Museum of New York. (Courtesy of Lonnie Gale.)

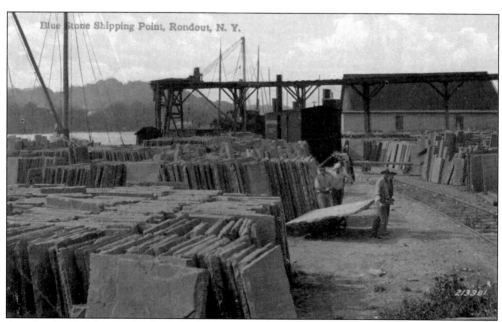

Another local industry also flourished. Bluestone was native to Ulster County and was prized for its properties as a construction material. (Courtesy of Trolley Museum of New York.)

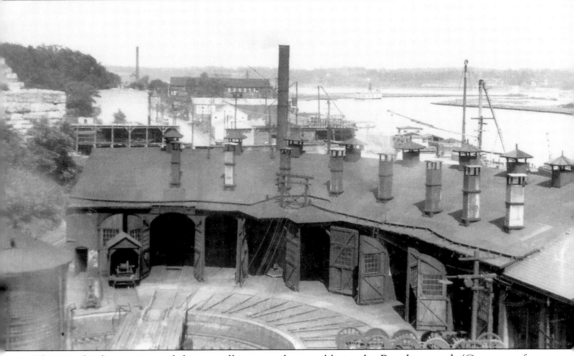

This is a bird's-eye view of the roundhouse and turntable in the Rondout yard. (Courtesy of Lonnie Gale.)

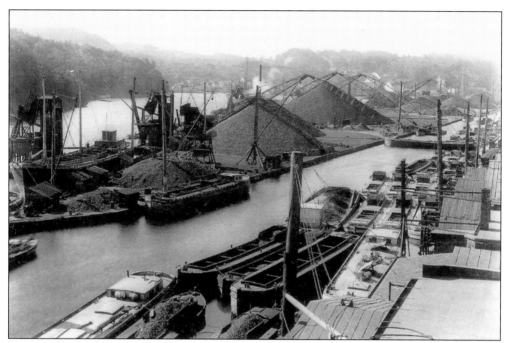

Kingston was a major transportation hub. It was blessed with a sheltered harbor in the mouth of the Rondout Creek at the Hudson River. The Delaware & Hudson Canal terminated here. The canal was built to accommodate barge traffic from Honesdale, Pennsylvania, to the Hudson River. On the left of the picture is the Rondout Creek. On the right is the Delaware & Hudson Canal. In the center is Island Dock, a man-made island used as a coal depository. There was a spur of the U&D Railroad, which served the docks here. (Courtesy of Lonnie Gale.)

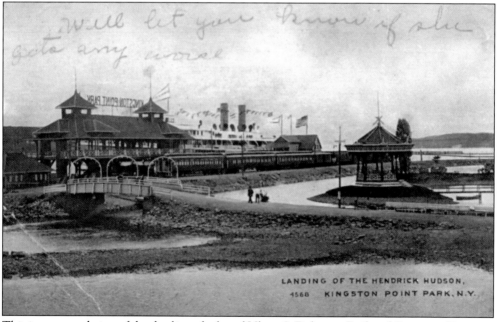

This is a postcard view of the day liner dock and Ulster & Delaware Railroad Station at Kingston Point on the Hudson River. (Courtesy of Vivian Yess Wadlin.)

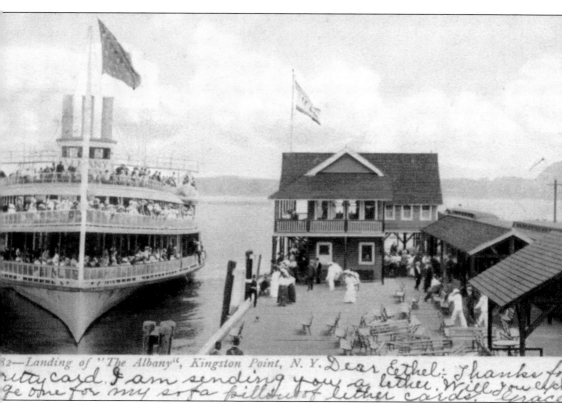

This is the end of the line of the U&D in Kingston. In this image, a day liner traveling up the Hudson River from points south is about to dock at Kingston Point. A passenger train is waiting at the right. Kingston Point Park was a tourist destination expressly built by the railroad and steamship company as a means to convey passengers to the amusements at this location. (Courtesy of Vivian Yess Wadlin.)

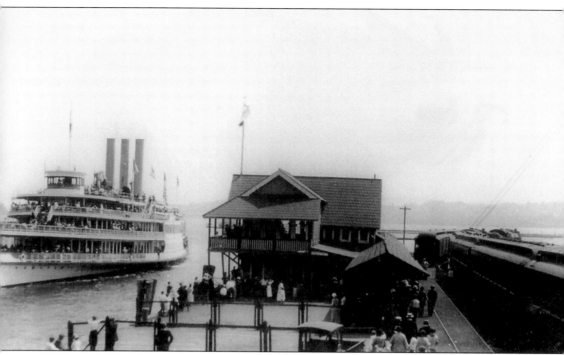

This was the era when public parks were conceived as natural spaces where urban residents could escape from the "built" environment of the city. Central Park in New York City was one of the most famous of all parks built during this era. Downing Vaux was the designer of Kingston Point Park. His father was Calvert Vaux, one of the codesigners of Central Park. Downing was named after one of his father's collaborators in landscape design, Andrew Jackson Downing. (Courtesy of Lonnie Gale.)

Five

THE WEST SHORE RAILROAD

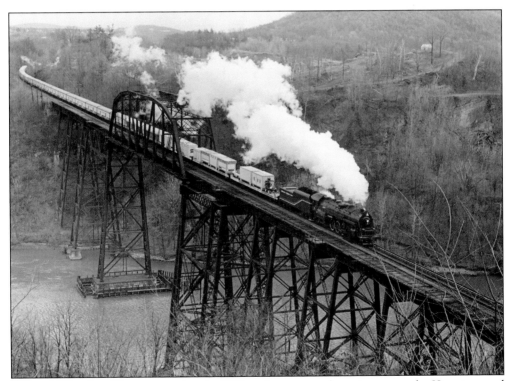

The 1976 Freedom Train is crossing the Wilbur Avenue trestle on its way to the Kingston yard to take on coal. The West Shore linked the other rail lines going through Ulster County and joined other major transportation hubs beyond Ulster County. It provided a detour, albeit greater distance, around a defunct Poughkeepsie Railroad Bridge. The CSX Corporation operates a thriving freight service today along the only surviving railroad in Ulster County. (Courtesy of Robert Haines.)

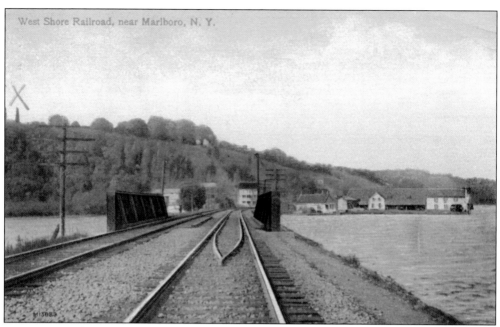

Passengers on the West Shore Railroad were treated to many beautiful views of the Hudson River and its environs. This is near Marlboro, looking south. During the years when the West Shore accommodated both freight and passenger service, a double track from Weehawken to Albany was necessary to handle the volume of traffic. This postcard is postmarked June 1918. (Courtesy of Vivian Yess Wadlin.)

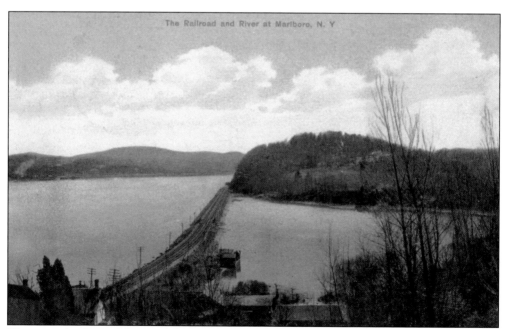

This is another beautiful vista of the West Shore Railroad tracks near Marlboro, New York, looking north. The postcard is postmarked September 6, 1908. (Courtesy of Vivian Yess Wadlin.)

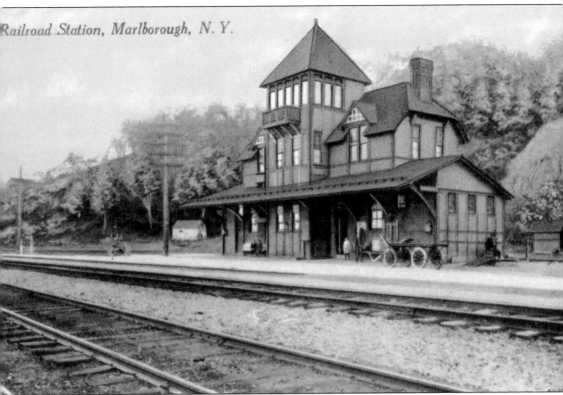

Railroad Station, Marlborough, N. Y.

Passenger service on the West Shore was discontinued in 1959. This is a postcard view of the West Shore Railroad Station in Marlboro. The railroad station in Marlboro, New York, on the West Shore Railroad was sold to the Mahans family with the proviso that they could have any of the materials in the station, but that the station would have to be torn down. Many parts of the station were salvaged by the Mahans to be used in their house. (Courtesy of Vivian Yess Wadlin.)

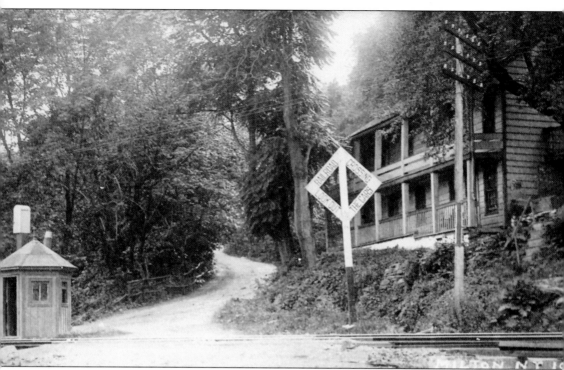

Structures of all different types played supporting roles for the railroad. A "watchman's shanty," the building shown above on the lower left, stands at the end of Dock Road, close to Peg's Point near Milton, New York. Its basic purpose was to provide protection for the watchman or crossing tender. On the West Shore, there were many rock cuts, which sometimes resulted in rock or mud slides onto the tracks. A shanty would be placed near one end of the rock cut. The watchman would record the time he began his trek through the cut, checking for slides. At the end of the cut, he would again record the time. This was proof that he had walked his assigned route. He would retrace his steps back to the shanty, again recording his time. (Courtesy of Friends of the Milton-on-Hudson Train Station.)

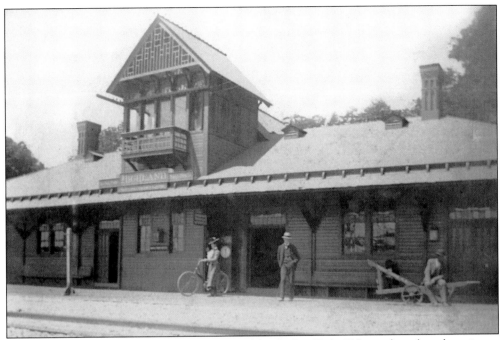

On March 1, 1883, at the ferry landing near Highland, New York, 200 people gathered to witness the passage of the first (work) locomotive riding the newly laid rails. The West Shore was opened for regular service on July 1, 1883. Most of the stations and freight houses were built soon thereafter. This looks to be a pleasant day at the West Shore Railroad Station in Highland, New York. A few people are waiting for the train. (Courtesy of Town of Lloyd Historical Collection.)

This is another view of the West Shore Railroad Station in Highland, New York. The photograph was taken in 1910. The more elaborate architectural design of the Highland Station indicates its importance on the West Shore Railroad. At this time, Highland was a transportation hub serving the Central New England Railway, ferries and day liners from Poughkeepsie, and the New Paltz–Highland Trolley Company. (Coauthor Glendon Moffett has authored several books on this subject). This building stands today as a converted apartment house. (Courtesy of Vivian Yess Wadlin.)

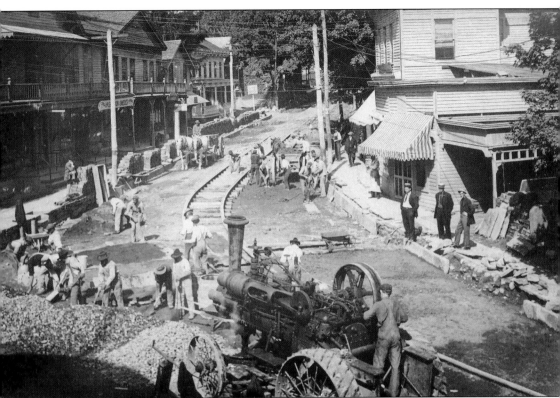

Workers are laying track for the trolley connecting the West Shore Railroad at Highland to New Paltz. The main purpose of this connection was for passenger and light freight service from Highland on the Hudson River to New Paltz. At the time, there was ferry service from Poughkeepsie, which this eight-mile trolley line could have served. Most trolley lines were built in urban areas with higher population densities. The New Paltz–Highland trolley was an early interurban line, the precursor of the light rail networks of today. (Courtesy of Vivian Yess Wadlin.)

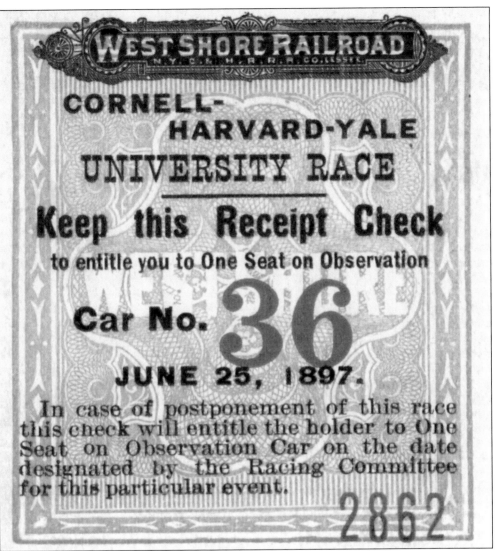

WEST SHORE RAILROAD

CORNELL-HARVARD-YALE UNIVERSITY RACE

Keep this Receipt Check

to entitle you to One Seat on Observation

Car No. **36**

JUNE 25, 1897.

In case of postponement of this race this check will entitle the holder to One Seat on Observation Car on the date designated by the Racing Committee for this particular event.

2862

This is a ticket for a ride in observation car No. 36 for the Cornell-Harvard-Yale race of June 25, 1897. The Harvard-Yale Boat Race or Harvard-Yale Regatta is an annual rowing race between Yale and Harvard. It was first contested in 1852 and has been held as an annual event since 1859 (except during the major wars fought by the United States). In 1897, the regatta was held on the Hudson River near Highland. Cornell was invited to join the competition between Yale and Harvard. The above picture is a scan of one of the tickets issued by the West Shore Railroad for passage on a train along the race course. The train consisted of an engine plus many flatcars. Bleachers installed on each flatcar provided seats for the passengers watching the regatta as it progressed along the Hudson River. (Courtesy of Town of Lloyd Historical Collection.)

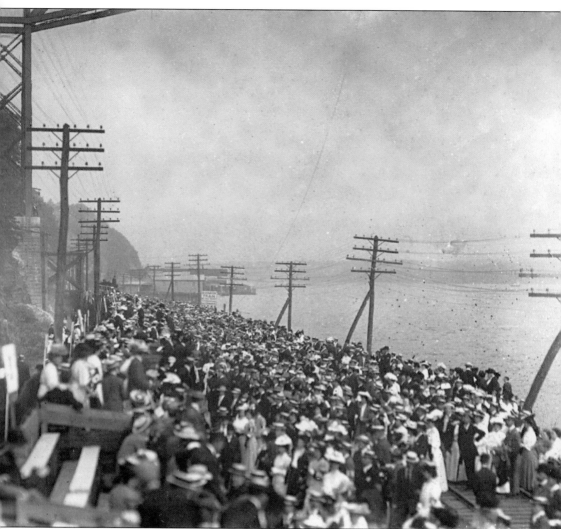

This picture (printed from a glass-plate negative) shows the crowd viewing the 1906 regatta between Cornell, Pennsylvania, Syracuse, Wisconsin, Columbia, and Georgetown Universities. The schools are listed in the order of finish in the varsity eights on June 23, 1906. Points of interest in the picture include the upper-left corner, where part of the superstructure of the Poughkeepsie Railroad Bridge is visible; the lower-right corner, where railroad track can be seen; and the lower-left, where bleachers are installed atop the flatcars. Another interesting feature of the picture is that all of the people standing on the ground are looking away from the Hudson River. They are most likely listening to reports of the race that were relayed to the spectators by spotters standing on the Poughkeepsie Railroad Bridge directly above them. (Courtesy of Charles Edward Courtney Papers Collection, Division of Rare and Manuscript Collections, Cornell University Library.)

A freight train on the West Shore Railroad is proceeding south in Lloyd, around 1895. This double-track line ran between Albany, New York, and Weehawken, New Jersey. (Courtesy of Elizabeth Werlau.)

Pictured here is a view of the northern end of the passing siding on the West Shore Railroad, near Highland, New York. The majestic Hudson River borders the West Shore line to the east. (Courtesy of Elizabeth Werlau.)

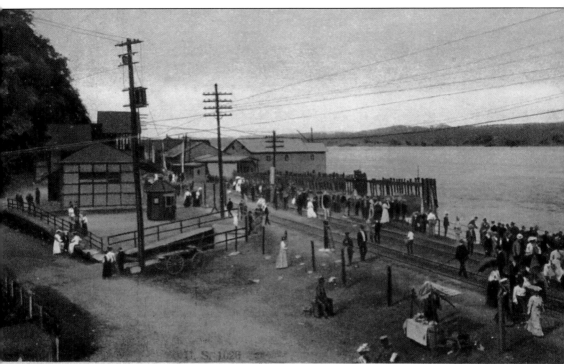

Highland, N. Y. West Shore Depot

Seen here is a northward view of the West Shore Railroad Depot complex in Highland, New York, which illustrates the popularity and multiple functions of this hub. The postage on this vintage postcard was 1¢, but it has no date on it. The piles in the Hudson River appear to be where the ferry landing is. The ferry crossed the river to Poughkeepsie, where passengers could transfer to the day liners that ran from Albany to New York City. This ferry service ran until December 31, 1941, when World War II fuel scarcity fully impacted the United States. On March 1, 1883, at the ferry landing near Highland, New York, 200 people gathered to witness the passage of the first locomotive to ride the newly laid rails. This locomotive had been used by the West Shore Railroad in laying the track. The West Shore was opened for regular service on July 1, 1883. (Courtesy of Elizabeth Werlau.)

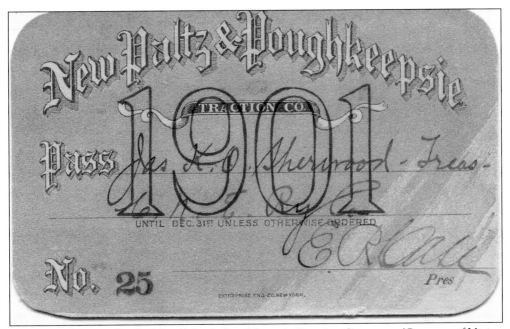

This is a ticket pass for the New Paltz & Poughkeepsie Traction Company. (Courtesy of Vivian Yess Wadlin.)

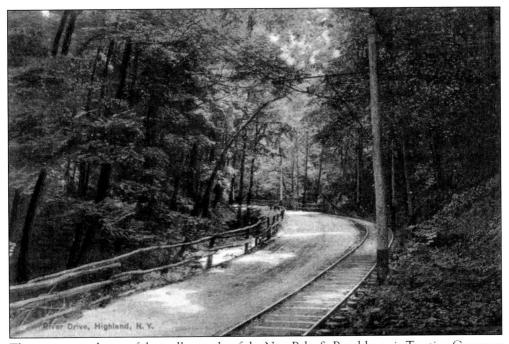

This is a postcard view of the trolley tracks of the New Paltz & Poughkeepsie Traction Company on River Drive in Highland. (Courtesy of Vivian Yess Wadlin.)

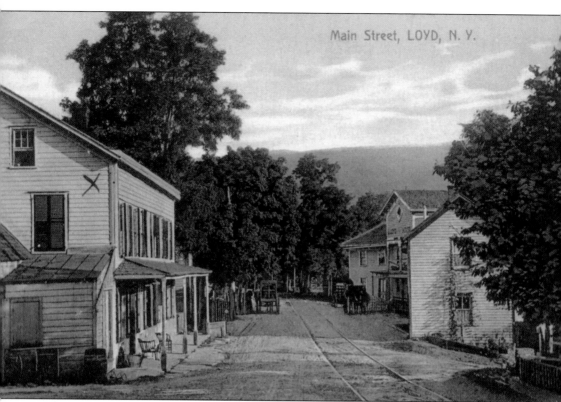

This is a view of the trolley tracks in Main Street in Loyd, just outside of the town of New Paltz. (Courtesy of Vivian Yess Wadlin.)

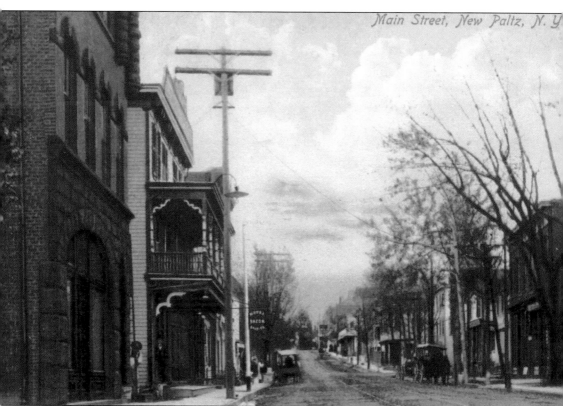

This is a postcard view of Main Street in New Paltz, showing the trolley tracks from Highland. Passengers could have transferred from the West Shore Railroad or the Central New England Railway in Highland and travelled west for about eight miles into New Paltz. Even though they could have made a connection with the Wallkill Valley Railroad in New Paltz, the connection in Kingston would have been more efficient and probably a bit faster. (Courtesy of Vivian Yess Wadlin.)

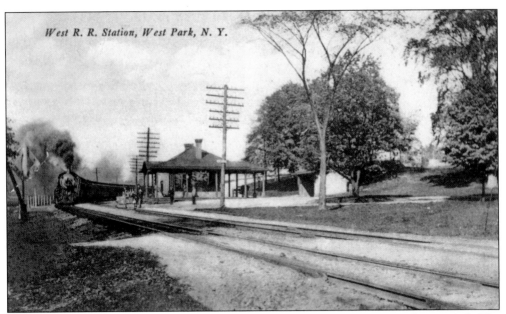

West R. R. Station, West Park, N. Y.

A West Shore train is passing through the railroad station in West Park (Esopus), New York. The West Shore line is no different from many of the historic and modern railroads; early images can be nostalgic, offering memories of places that have been changed or lost. West Park (as well as Esopus below) remains rural in character today; indeed, many of the old farmers' fields on hillsides have been overgrown with forest. The only remaining evidence is the stone walls that the farmers built as they were clearing the fields. (Courtesy of Vivian Yess Wadlin.)

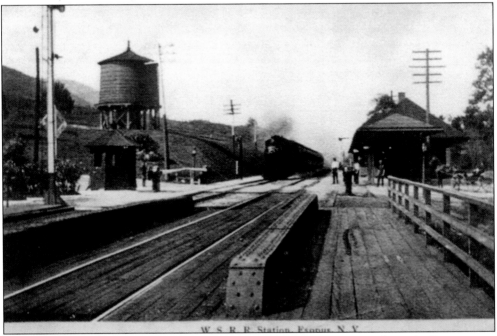

W. S. R. R. Station, Esopus, N. Y.

This is a postcard view of a West Shore Railroad passenger train approaching the Esopus train station at Albany Post Road. The familiar water tower stands on the left side. Also, just below and in front of the water tower is a watchman's shanty. (Courtesy of Vivian Yess Wadlin.)

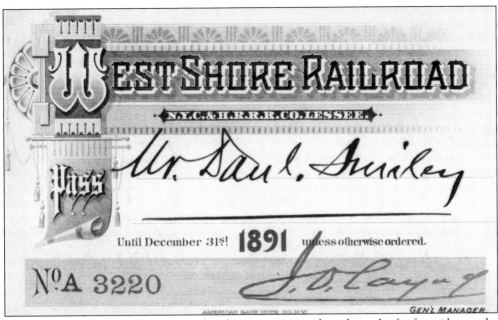

This is an image of a West Shore Railroad pass, given to selected people, for free rides on the West Shore Railroad. This pass expired December 31, 1891. The name on the pass is Mr. Daniel Smiley (1855–1930), half-brother of the founding twin brothers (Albert and Alfred) of the Mohonk Mountain House, located outside of New Paltz, New York. Smiley sometimes made the trip north from New York City. He would switch trains at Kingston's Union Station, boarding a southbound passenger train of the Wallkill Valley Railroad, getting off at New Paltz. From there, he would be conveyed by carriage to the Mohonk Mountain House. (Courtesy of Vivian Yess Wadlin.)

"Mr. Dan," as he was known at the Mohonk Mountain House, often had both personal and business items shipped via freight on the West Shore Line. Mr. Dan was 27 years younger than Albert, who invited him to become part of the management team at Mohonk sometime in the 1880s. The route to the Mountain House, as hand-painted on the lower crate, indicates, "PRR [Pennsylvania Railroad] VIA PENNA WEST SHORE WALLKILL VALLEY RR." The other travel alternative could have been to disembark from the West Shore Railroad in Highland and board the trolley for New Paltz. Upon his arrival in New Paltz, he would have been met by a carriage sent down from the Mountain House. (Photograph by Steve Ladin; courtesy of the Barn Museum, Lake Mohonk Mountain House.)

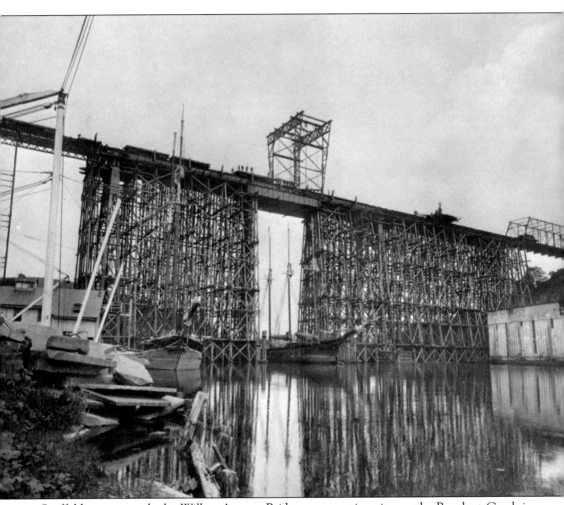

Scaffolding surrounds the Wilbur Avenue Bridge construction site on the Rondout Creek in Kingston. A schooner passes beneath the bridge to accurately gauge safe passage of shipping traffic. Allowances for variations in high and low tides had to be taken into consideration. (Courtesy of Robert Haines.)

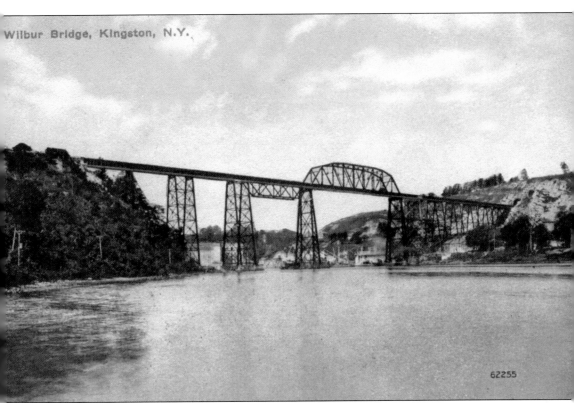

Wilbur Bridge, Kingston, N.Y.

62255

This view looks east toward the West Shore Railroad Wilbur Avenue Bridge, spanning the Rondout Creek, just before reaching Kingston, New York. The postcard is postmarked February 23, 1911. (Courtesy of Vivian Yess Wadlin.)

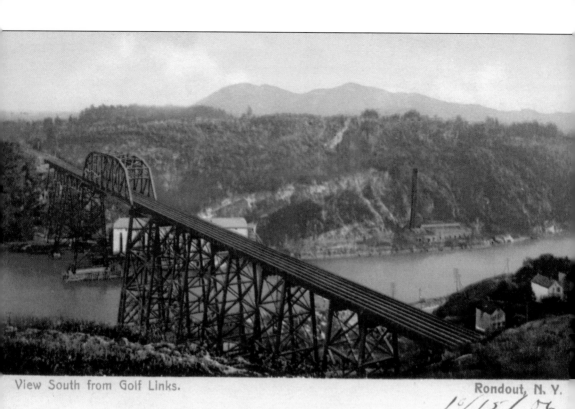

View South from Golf Links. Rondout, N. Y.

10/15/06

Dave

This is a view, looking northeast, of the West Shore Railroad Wilbur Avenue Bridge over the Rondout Creek in Rondout, New York. The postcard is postmarked October 16, 1911. (Courtesy of Vivian Yess Wadlin.)

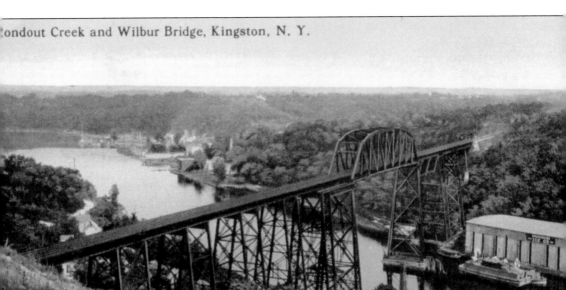

This is a northwest view of the West Shore Railroad Bridge over the Rondout Creek near Kingston, New York. An icehouse is visible in the lower right. (Courtesy of Vivian Yess Wadlin.)

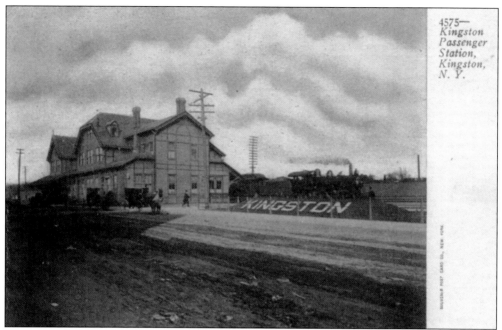

This is a south-looking view of the Kingston Union Station adjacent to the West Shore tracks. (Courtesy of Vivian Yess Wadlin.)

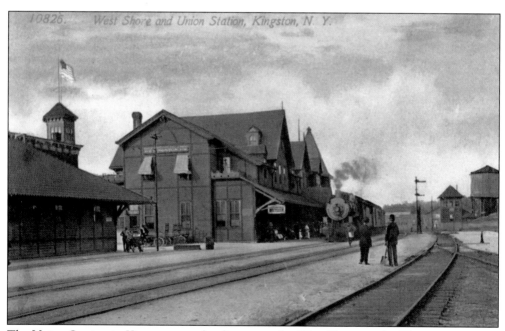

The Union Station in Kingston stands adjacent to the West Shore tracks. The water tower is visible on the right. Its capacity had to be greater because it served more engines. (Courtesy of Vivian Yess Wadlin.)

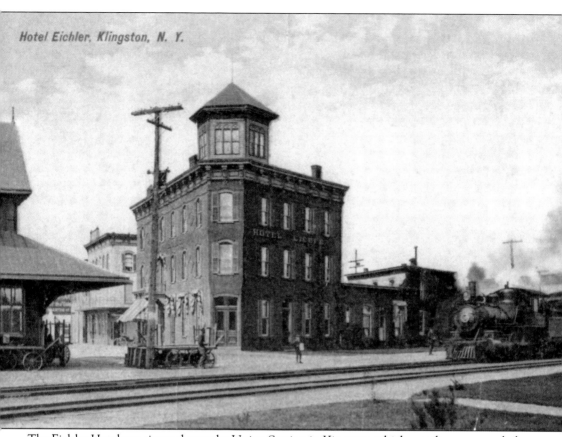

Hotel Eichler, Klingston, N. Y.

The Eichler Hotel was situated near the Union Station in Kingston, which was the passenger hub of the Wallkill Valley Railroad, the Ulster & Delaware Railroad, and the West Shore Railroad. (Courtesy of Vivian Yess Wadlin.)

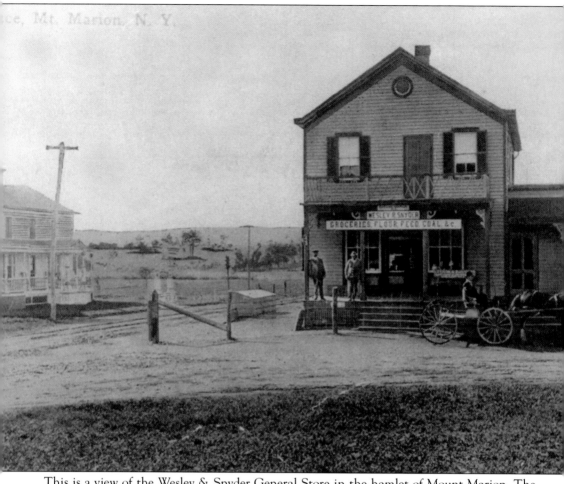

This is a view of the Wesley & Snyder General Store in the hamlet of Mount Marion. The tracks of the West Shore are visible on the left. This photograph hangs on the wall in the Mount Marion Post Office. It was discovered by railroad buff Joseph Leister. (Courtesy of Mount Marion postmaster.)

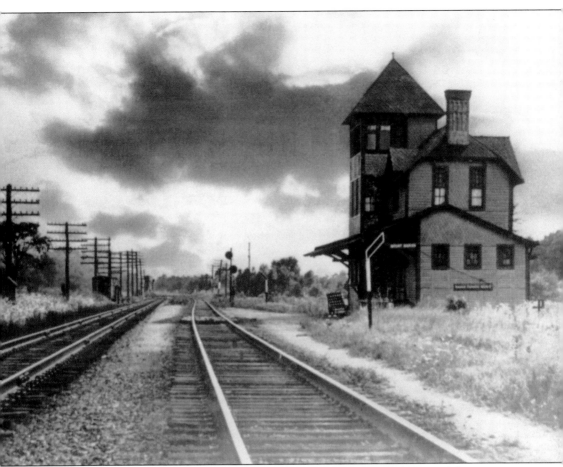

This is a view of the Mount Marion Railroad Station. This was a second photograph hanging on the wall in the Mount Marion Post Office. (Courtesy of Mount Marion postmaster.)

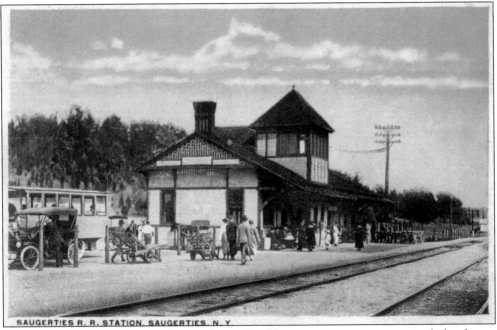

SAUGERTIES R. R. STATION, SAUGERTIES, N. Y.

Saugerties, a village approximately 12 miles north of Kingston, was a transportation hub, of sorts. The railroad station here has a similar architectural design to the Highland Station pictured previously in this chapter. (Courtesy of Vivian Yess Wadlin.)

This is a view of the freight station at Saugerties, New York. It was designed by the Wilson Brothers and Company of Philadelphia, Pennsylvania. This company also designed the railroad station in Milton, New York, erected in 1883. (Courtesy of Elizabeth Werlau.)

Six

THE WALLKILL VALLEY RAILROAD

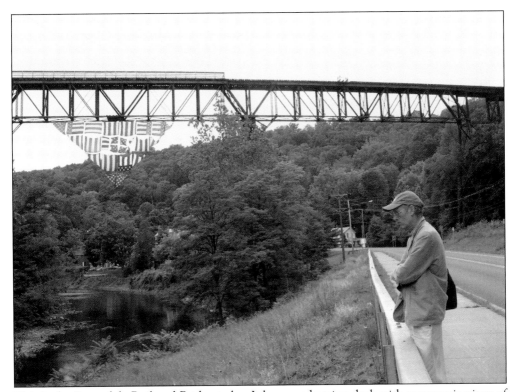

This is the Rosendale Railroad Bridge today. It has a pedestrian deck with panoramic views of the village of Rosendale and its environs. (Courtesy of Steve Ladin.)

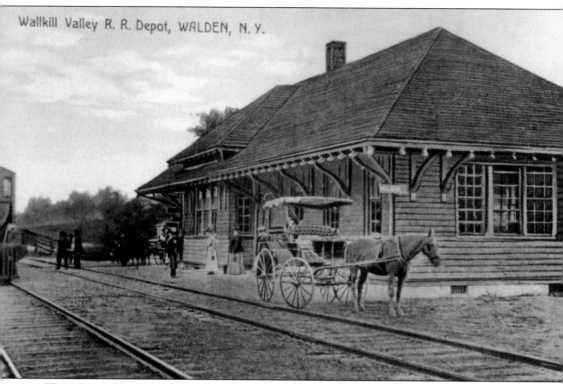

Wallkill Valley R. R. Depot, WALDEN, N. Y.

The village of Walden is located in Orange County, just south of the border with Ulster County. This scene at the Walden Station could have been repeated almost anywhere along the line. The depots all along the Wallkill Valley (WV) Railroad shared a common architecture. The Wallkill River Valley, from which the railroad appropriated its name, was and still is famous for the "black dirt" farms known for growing onions. The river still floods (almost annually) at various places, creating fertile fields in the flood plains. The rural character of the lands adjacent to the old railroad corridor (now a heavily used and appreciated rail trail) retain their natural beauty. (Courtesy of Elting Memorial Library.)

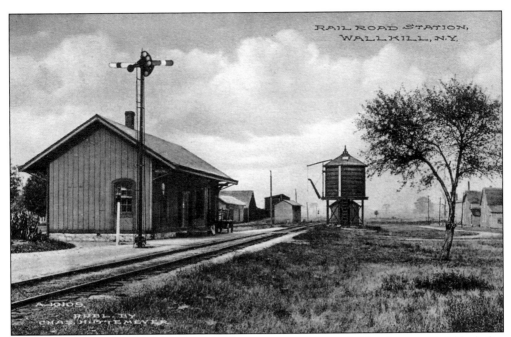

Wallkill, New York, was in the middle of farm country, surrounded by the so-called black dirt onion farms. (Courtesy of Elizabeth Werlau.)

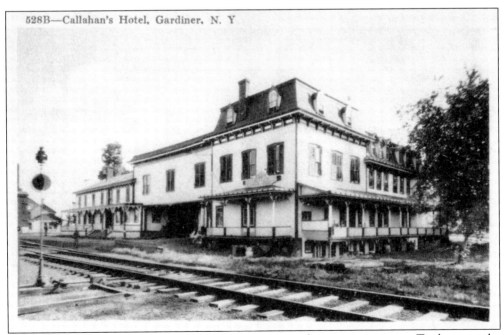

Gardiner, located in south-central Ulster County, was a farming community. To the west, the Shawangunk Ridge loomed; to the east was the Hudson River. With the advent of railroad service, rest homes and hotels sprang up to serve vacationers escaping the heat and congestion of the cities. (Courtesy of Shirley Anson.)

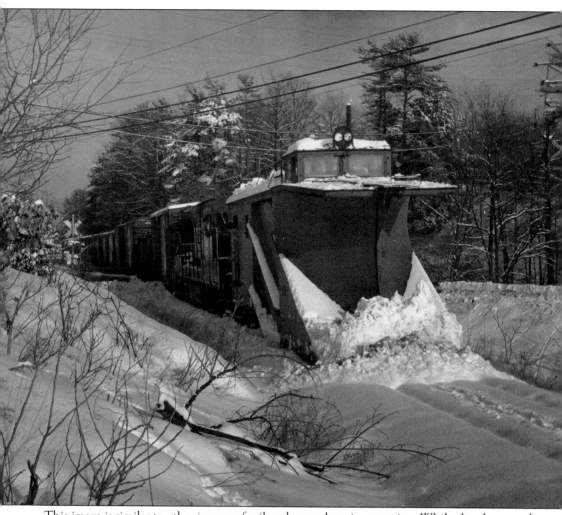

This image is similar to other images of railroad snowplows in operation. While the photograph is not dated, it may have been taken in the late 1960s. The plow is leading a line of freight cars just south of the Kingston rail yards. (Courtesy of Robert Haines.)

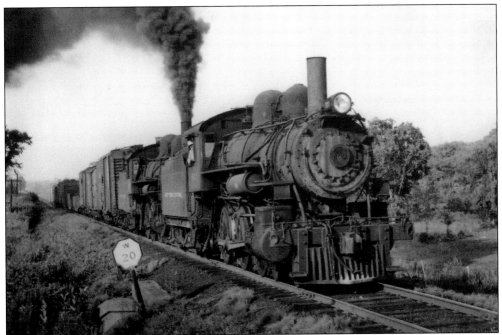

Two steam locomotives are pulling what appears to be a freight train consisting of only five or six cars. Smoke is coming out of the second locomotive. It is not clear if the lead locomotive is active, or is being pushed. The engineer in front may be acting as a signalman. (Courtesy of Robert Haines.)

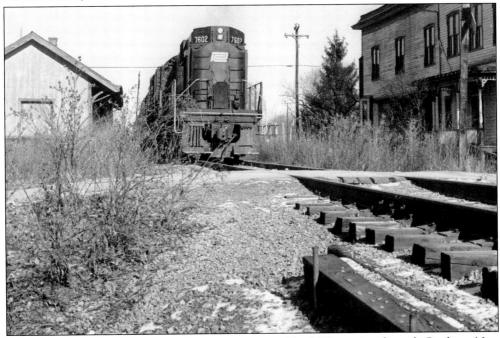

This photograph is dated January 6, 1973. Locomotive No. 7602 is going through Gardiner, New York (southern Ulster County). This was very near the end of service on the Wallkill Valley Railroad. (Courtesy of Robert Haines.)

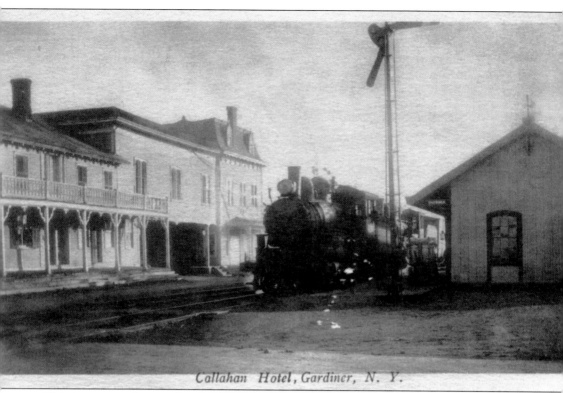

Callahan Hotel, Gardiner, N. Y.

This is a postcard view of a train on the Wallkill Valley Railroad tracks (from about 1900) in Gardiner with the Callahan Hotel on the left and the train station on the right. (Courtesy of Vivian Yess Wadlin.)

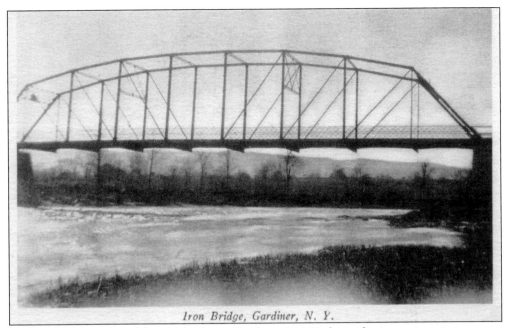

Iron Bridge, Gardiner, N. Y.

This is a postcard view of the iron bridge in Gardiner, New York, similar in construction to many iron bridges spanning rivers of a similar width. (Courtesy of Vivian Yess Wadlin.)

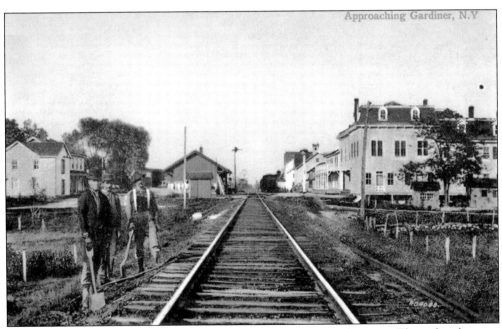

Approaching Gardiner, N.Y

This is a postcard view of the Callahan Hotel from the opposite direction. The railroad station is on the left, and the Callahan Hotel is on the right. (Courtesy Vivian Yess Wadlin.)

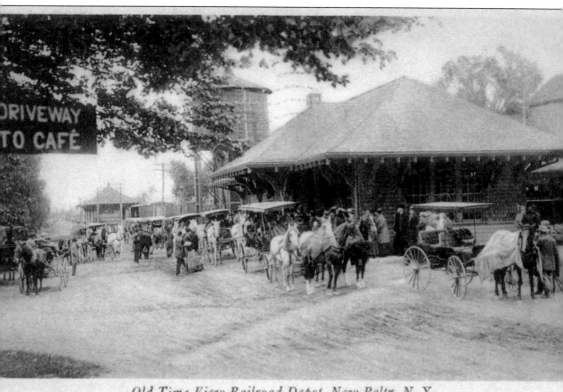

Old Time View Railroad Depot, New Paltz, N. Y.

This is a postcard of the Wallkill Valley Railroad depot in New Paltz, New York, during a busy time, probably in the summer. Most of the railroad stations along the Wallkill Valley Railroad are similar in style but varying in size. A number of them have survived and have been restored. They continue to function as private residences, commercial establishments, and art centers. The water tank is looming over the left section of the station roof. Water was an essential component for steam engine operations; water tanks are interesting and historic architectural features along many rail lines of yesteryear. (Courtesy of Vivian Yess Wadlin.)

Scene on Wallkill Valley R. R., New Paltz Depot in the distance, New Paltz, N. Y.

This is a 1911 postcard view, looking south, of the Wallkill Valley Railroad tracks with the New Paltz depot, seen as a yellow spot to the right at the end of the visible track. (Courtesy of Vivian Yess Wadlin.)

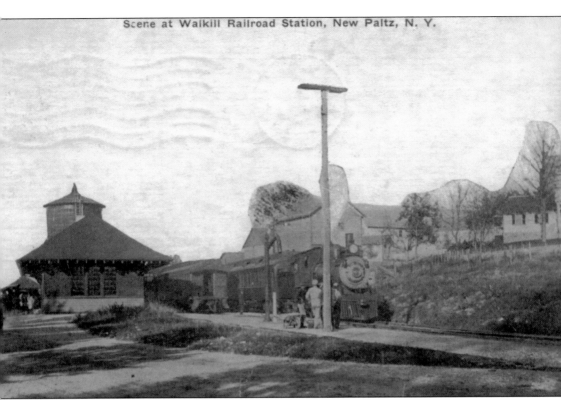

A passenger train heading south is waiting at the Wallkill Valley Railroad Station in New Paltz, New York. This postcard is dated 1914. (Courtesy of Vivian Yess Wadlin.)

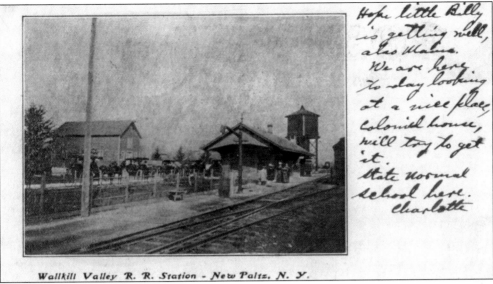

Wallkill Valley R. R. Station - New Paltz, N. Y.

Old postcards are interesting for the hand-painted color applied over the original mono-color lithographs (the postcards were sent to Germany, where they were colored by hand). Just as interesting are the notes sent via the mail to loved ones. The note on this card references the State Normal School, which is now the State University of New York (SUNY), New Paltz. It appears as if Charlotte is looking into buying a house in New Paltz. The postcard is dated 1909. (Courtesy of Vivian Yess Wadlin.)

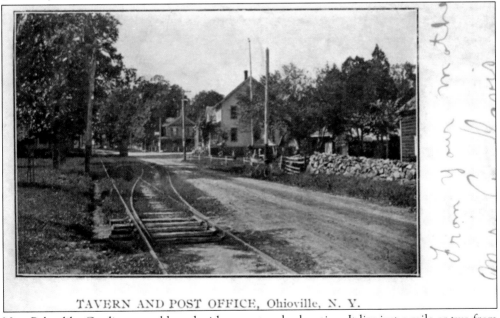

TAVERN AND POST OFFICE, Ohioville, N. Y.

New Paltz, like Gardiner, was blessed with a spectacular location. It lies just a mile or two from the Shawangunk Ridge. Atop the ridge outside of New Paltz is the renowned Lake Mohonk Mountain House. An early example of an interurban rail line ran east-west from Highland/Loyd into the village. It brought passengers and light freight from the connection of the West Shore Railroad in Highland and the ferry from Poughkeepsie. This photograph shows the crossroads hamlet of Ohioville. (Courtesy of Elizabeth Werlau.)

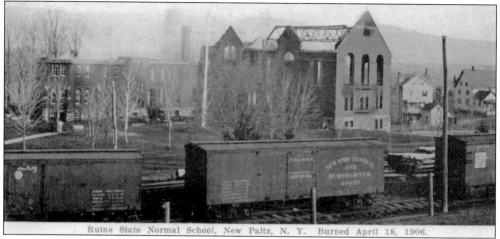

This postcard, dated April 18, 1906, pictures the Wallkill Valley Railroad with a New York Central boxcar on a siding. In the background are the remains of the State Normal School in New Paltz, New York, after a fire. At the time of the photograph, the State Normal School trained individuals interested in entering the teaching profession. SUNY New Paltz remains a well-regarded teachers college and has earned a national reputation as a school for the fine arts. (Courtesy of Vivian Yess Wadlin.)

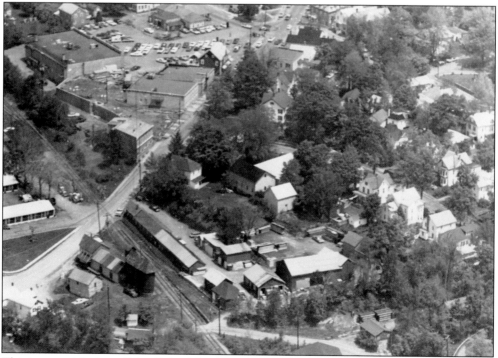

This is an aerial view of New Paltz. Main Street cuts from the lower left to the upper center of the photograph. The WV railroad tracks can be seen going diagonally from the lower center, crossing Main Street, leaving the picture at the left center (traveling north). The buildings on either side of the tracks below Main Street were part of the New Paltz Lumber Company and yard. The buildings have been rehabilitated and are now the Water Street Market, a popular destination for tourists and residents. (Courtesy of Robert Haines.)

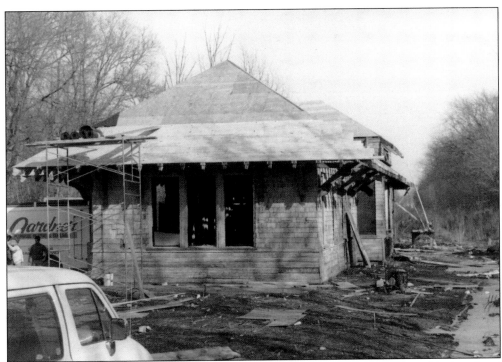

This is a photograph of the New Paltz Station prior to its rehabilitation. It had been abandoned and was derelict until the 1980s. It is now the home of a restaurant. The restoration additions have retained the character and style of the original architecture. (Courtesy of Elting Memorial Library.)

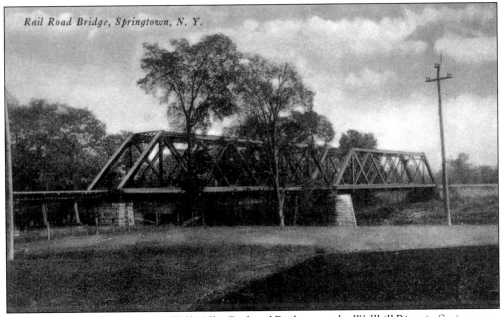

This is a postcard view of the Wallkill Valley Railroad Bridge over the Wallkill River in Springtown, several miles north of New Paltz, New York. (Courtesy of Vivian Yess Wadlin.)

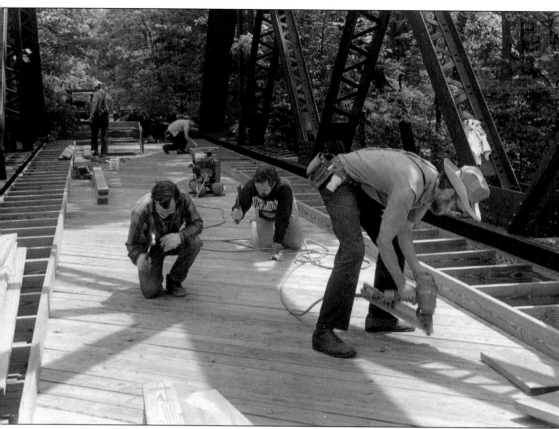

This is a photograph of the volunteer crew building a pedestrian deck on the Wallkill Valley Railroad Bridge. Over the course of several weeks, a crew of as many as 100 volunteers completed the decking, benches, and safety railings. The rail-trail bridge is several miles north of the village of New Paltz. It spans the Wallkill River at a beautiful spot populated by fish and many fowl. Abandoned railroad right-of-ways were acquired by state and local agencies and then leased or their administration turned over to nonprofit organizations. In this case, the Wallkill Valley Rail Trail Association administers and maintains the rail trail, while the local townships through which the rail trail passes retain ownership and contribute to their operation. Other stakeholders, such as the Open Space Institute and the Wallkill Valley Land Trust, offer assistance, guidance, and funding to keep these parks open and enjoyed by the public. (Courtesy of Elting Memorial Library.)

The first Rosendale Railroad Bridge was constructed in 1871. In this photograph, construction workers can be seen atop wooden scaffolding on the southern half of the structure. The steel structural framework has been completed on the north half of the trestle. The Rondout Creek flows freely on the left; the Ulster & Delaware Canal is the water channel on the right. (Courtesy of Elting Memorial Library.)

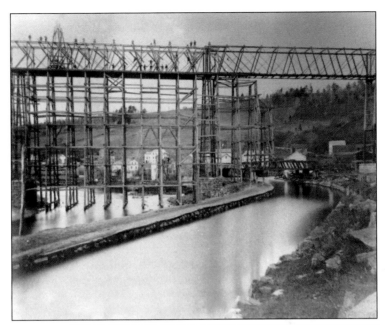

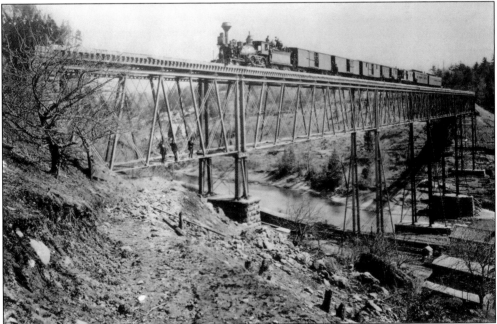

On April 6, 1872, the Rosendale Railroad Bridge opened for train traffic. As was typical in the day, passengers celebrated the event by riding on and in the train, as well as clinging to various parts of the bridge. A cluster of onlookers appears at the left side of the bridge end as well as on the lower portion of the super structure. This bridge was replaced around 1900 to accommodate heavier locomotives. This image is similar to the photograph of the opening of the Poughkeepsie Railroad Bridge. Onlookers and dignitaries were enthusiastic in their celebration of the opening of the bridge. The Delaware & Hudson Canal can be seen below the bridge. Below the bridge is Lock No. 7 of the canal. The structures on the lower right served canal-related functions, such as icehouses, cement mine sheds, or coal or blue stone storage. (Courtesy of Robert R. Haines.)

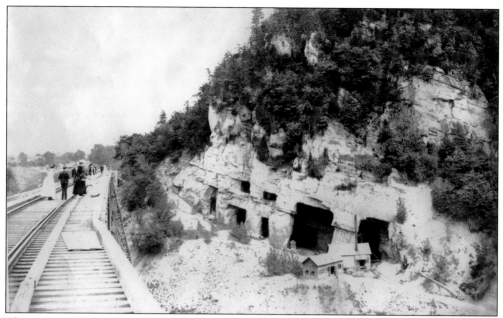

This is a scene at the northern side of the Rosendale Railroad Bridge. On the right is Mount Joppenburgh. The openings in the mountain are cement mines, one of the sources of the famous and remarkably durable Rosendale Cement. This photograph is dated around the 1880s. An event on or near the bridge was probably being celebrated, which would explain the people on the bridge dressed in their Sunday best. The square openings on the right are the cement mines; these particular mines caved in, and the openings are no longer visible to the casual observer. (Courtesy of Robert Haines.)

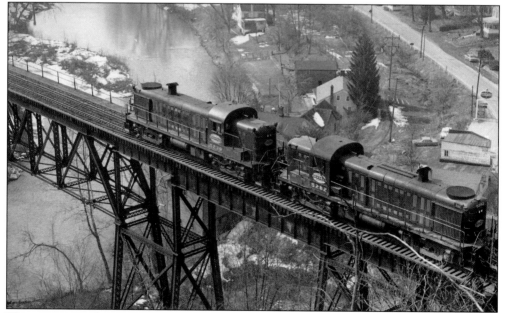

This is a spectacular view of two locomotives pulling a freight train across the Rosendale Railroad Bridge on March 19, 1969. The vantage point of the photograph is from Mount Joppenburgh. Below the bridge are Route 213 and the Rondout Creek. (Courtesy of Robert Haines.)

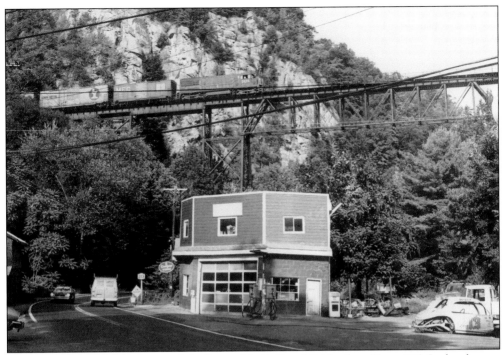

This is a view looking back toward the Rosendale Railroad Bridge from Route 213. It also shows a southbound freight, this time with only one locomotive. Mount Joppenburgh is in the background. (Courtesy of Robert Haines.)

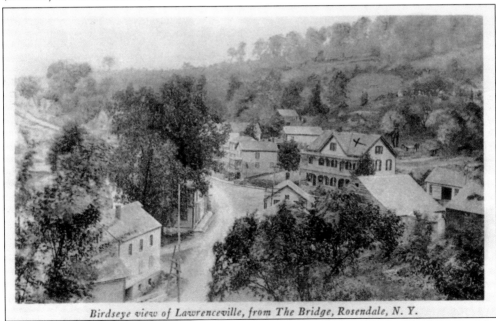

Birdseye view of Lawrenceville, from The Bridge, Rosendale, N. Y.

This is a postcard view of Lawrenceville from the Rosendale Railroad Bridge (also known as the Wallkill Valley Railway Bridge) in Rosendale, New York. Lawrenceville is a hamlet just west of the village of Rosendale. Many of the structures pictured still stand today. (Courtesy of Vivian Yess Wadlin.)

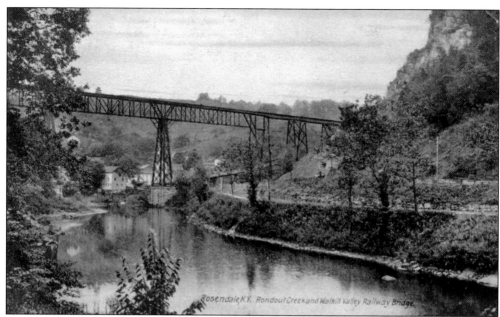

This is another postcard view of the Rosendale Railroad Bridge over the Rondout Creek in Rosendale. This is the second bridge, replacing the one seen on page 121. The vertical steel support structure has been rebuilt to accommodate heavier loads traveling at faster speeds. (Courtesy of Shirley V. Anson.)

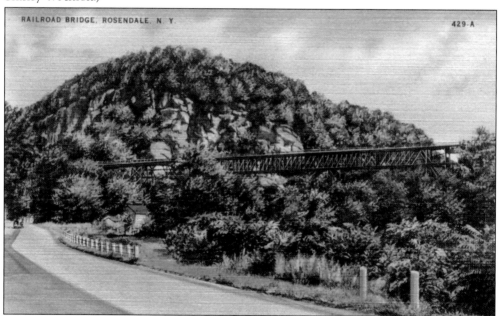

This is a view from what is now Route 213, looking east. The horizontal structure of the Wallkill Valley Railway Bridge over the Rondout Creek in Rosendale is visible. Mount Joppenburgh is in the background; an early sidewalk runs from the right bottom to the center left. State Route 213 is on the left, barely in the picture. The scene is almost identical to its appearance today. The authors surmise the date of this postcard to be around the 1940s–1950s. (Courtesy of Vivian Yess Wadlin.)

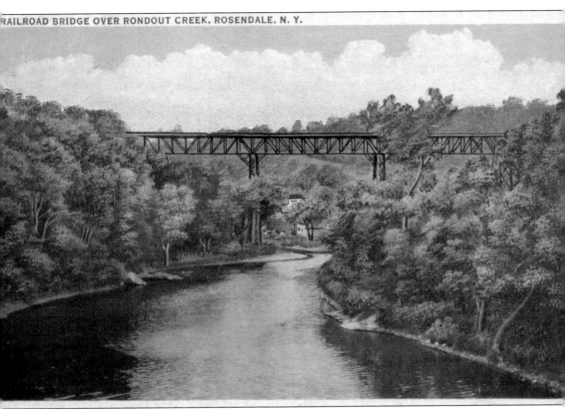

This is another view of the railroad bridge over the Rondout Creek in Rosendale, New York. The vantage point is from an automobile bridge spanning the creek and looking west. This bridge connected Springtown/Elting Corners Road with Route 213, an alternate to the north-south State Route 32 between New Paltz with Rosendale/Route 213. (Courtesy of Vivian Yess Wadlin.)

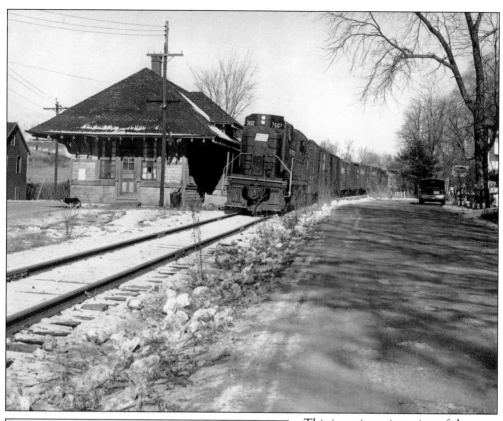

This is a wintertime view of the Binnewater Station, approximately one mile north of Rosendale. At the time the photograph was taken in 1973, this was the Wallkill Valley Branch of the Penn Central Railroad. This southbound freight originated in Kingston and terminated in Campbell Hall, Orange County. The architecture of the Binnewater Station is similar to that of the New Paltz depot and the others along the Wallkill Valley line. (Courtesy of Robert Haines.)

This is Union Station in Kingston with an RS2 locomotive, posing sometime in 1960. Regular passenger service had been suspended at this time. (Union Station was abandoned in 1958.) There were excursion trains, on rare occasions, up until the 1970s. (Photograph by Robert Haines.)

CENTURY CEMENT PLANT, ROSENDALE, N. Y.

Natural cement was mined throughout the town of Rosendale and in other places in Ulster County, including Kingston. The cement was burned in nearby kilns. The WV Railroad had a spur from the Binnewater Station to the Century Cement plant. In the photograph are hopper cars of the Wallkill Valley Railroad. The cement could be transported by the WV Railroad to Kingston, where it would be loaded on barges or continue on another railroad to just about anywhere in North America. The Ulster & Delaware Canal traveled through Rosendale (it was adjacent to the Rondout Creek, an integral part of the canal). Coal from Haynesville, Pennsylvania, could be off-loaded in Rosendale for use in the cement kilns. Barrels of cement could be put on the now empty barges for transport to Kingston and the Hudson River, or back towards Pennsylvania. Rosendale Cement was prized for its hardness. It was used in many of the monumental constructions of the day, including the Brooklyn Bridge and the Washington Monument. Modern contractors often comment on how difficult it is to demolish a structure built with Rosendale Cement. The Century House Historical Society maintains a museum and an extensive archive on Rosendale's cement industry. The Delaware & Hudson Canal Museum (located in High Falls, a village several miles west of Rosendale) also maintains an archive. This area of Ulster County is a snapshot of the golden age of the industrial growth in America from the 1880s to 1940s. (Courtesy of Vivian Yess Wadlin.)

DISCOVER THOUSANDS OF LOCAL HISTORY BOOKS
FEATURING MILLIONS OF VINTAGE IMAGES

Arcadia Publishing, the leading local history publisher in the United States, is committed to making history accessible and meaningful through publishing books that celebrate and preserve the heritage of America's people and places.

Find more books like this at
www.arcadiapublishing.com

Search for your hometown history, your old stomping grounds, and even your favorite sports team.

Consistent with our mission to preserve history on a local level, this book was printed in South Carolina on American-made paper and manufactured entirely in the United States. Products carrying the accredited Forest Stewardship Council (FSC) label are printed on 100 percent FSC-certified paper.

MADE IN THE